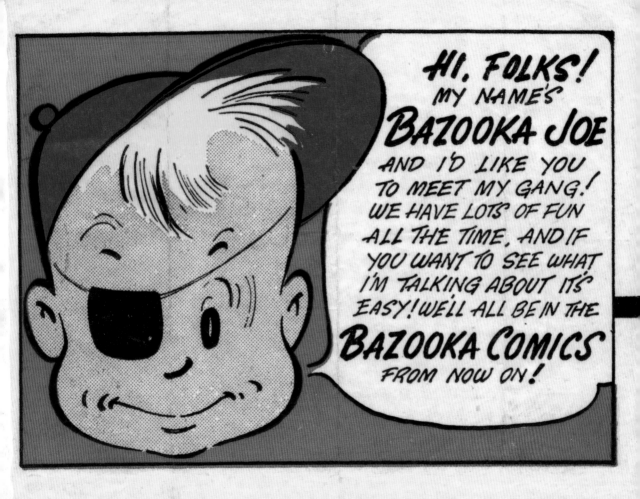

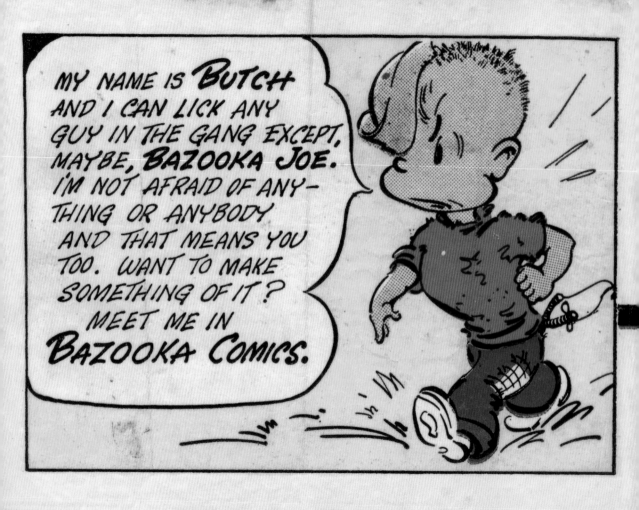

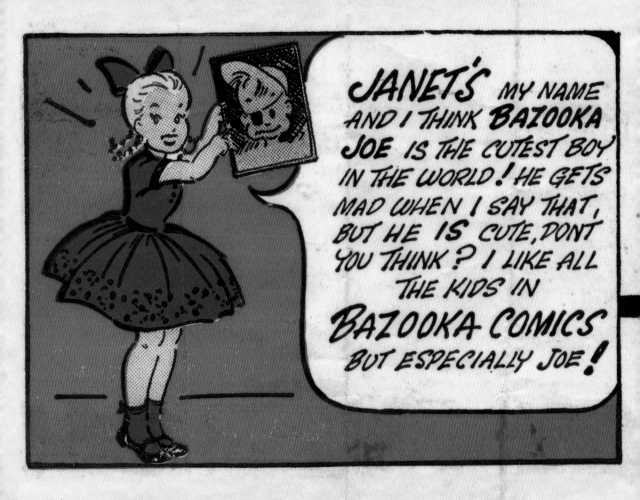

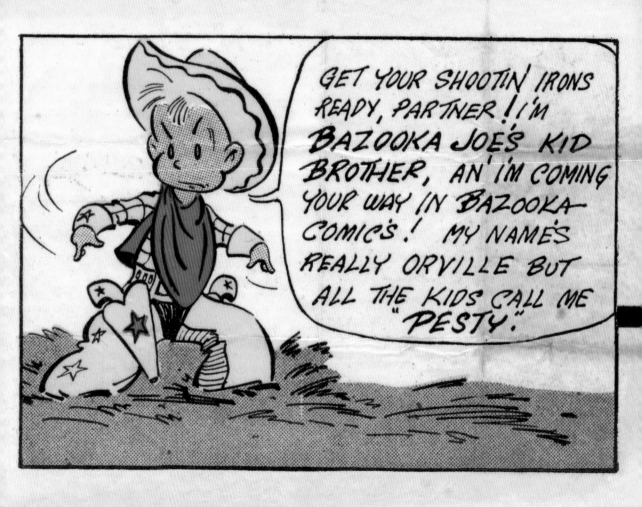

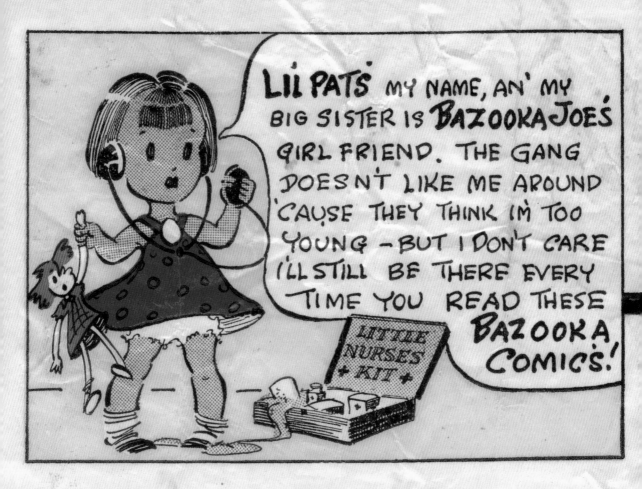

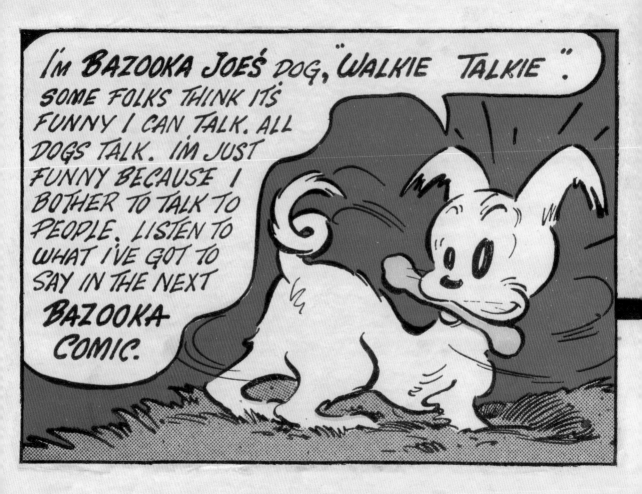

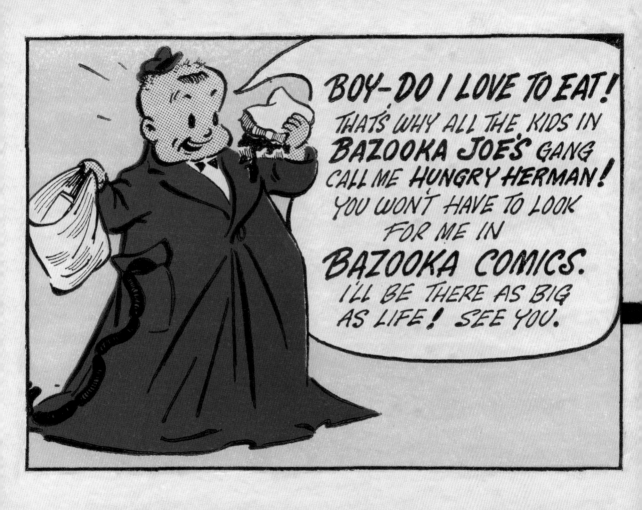

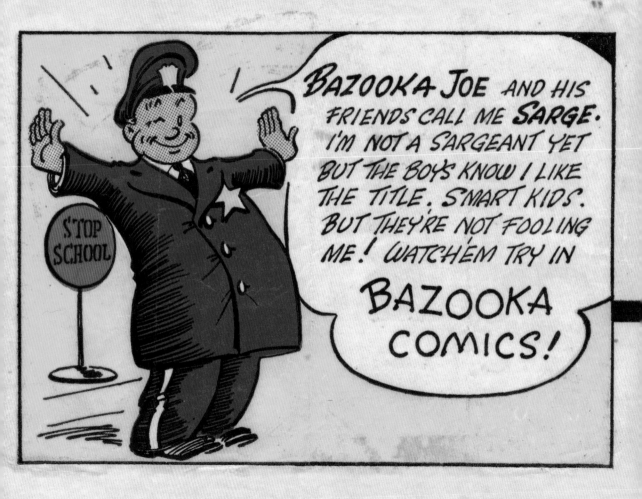

Bazooka

JOE and his GANG™

By The Topps Company, Inc.

SELECTED BY AND FROM THE COLLECTION OF JEFF SHEPHERD

PREFACE BY TALLEY MORSE
INTRODUCTION BY NANCY MORSE AND KIRK TAYLOR
ESSAYS BY LEN BROWN, R. SIKORYAK, AND BHOB STEWART
AFTERWORD BY JAY LYNCH

Abrams ComicArts, New York

TO THE SHORIN FAMILY, WHOSE VISION, CREATIVITY, AND PERSEVERANCE ENTERTAINED GENERATIONS
OF LOVING FANS AND PROVIDED A FUN PLACE TO WORK FOR THOUSANDS OF DEDICATED TOPPS EMPLOYEES

ACKNOWLEDGMENTS: Thanks to Ira Friedman and Adam Levine at Topps; Len Brown, Jay Lynch, Nancy Morse, Talley Morse, Bob Sikoryak, Bhob Stewart, and Kirk Taylor (for editorial contributions, as well as patience, generosity, and all-around availability to help this book come together); Art Spiegelman (guidance and moral support); and Jeff Shepherd (for generously donating his collection and his time to make this book a reality. Without you, Jeff, this would have been just a random collection of comics). At Abrams ComicArts: Charles Kochman (editorial); Clarissa Wong (editorial assistance); Chad W. Beckerman, Sara Corbett, and Robyn Ng (design); David Blatty (managing editorial); and Alison Gervais (production and flexibility beyond measure). Also: Les Davis, *The Wrapper* (www.thewrappermagazine.com); Roxanne Toser and Harris Toser, *Non-Sport Update* (www.nonsportupdate.com); David Hornish at the Topps Archives blog (www.toppsarchives.blogspot.com); Frederick and Karen Taylor; Ben Berkley, Alyssa Wise, and Grant Ossler at the *Onion*; Bob Conway; Peter Maresca; and Gene Weingarten at the *Washington Post*. Finally, a very special thank-you to Woody Gelman and Wesley Morse for the creation of this material.

Editor: Charles Kochman
Editorial Assistant: Clarissa Wong
Designers: Chad W. Beckerman, Sara Corbett, and Robyn Ng
Managing Editor: David Blatty
Production Manager: Alison Gervais

Library of Congress Cataloging-in-Publication Data:

Topps Company.
 Bazooka Joe and His Gang / by The Topps Company, Inc. ;
selected by and from the collection of Jeff Shepherd ; preface
by Talley Morse ; introduction by Nancy Morse and Kirk
Taylor ; essays by Len Brown, R. Sikoryak, and Bhob Stewart ;
afterword by Jay Lynch.—1 [edition].
 pages cm
 ISBN 978-1-4197-0632-5 (hardback)
 1. Morse, Wesley, 1897–1963—Themes, motives.
 2. Bazooka Joe and his gang (Comic strip) 3. Shepherd, Jeff–
Art collections. I. Title.
 NC1764.5.U62M672 2013
 741.5'973—dc23

COVER DESIGN: Sara Corbett
CASE PHOTOGRAPHY: Geoff Spear
OPPOSITE: Presentation piece by Wesley Morse, c. 1954.

Although Bazooka Joe was created in 1953, the first printed material was released to the public in Spring 1954.

The advertisements reprinted in this publication are included for historical and editorial purposes only. All offers are no longer valid.

The views expressed in the editorial commentary are solely those of the individuals providing them and do not represent the opinions of The Topps Company or the publisher.

For further information about Bazooka Joe, please visit www.bazookajoe.com and www.topps.com, or contact Jeff Shepherd at www.bubblegumarchives.com or at jeffshep77@gmail.com.

ABRAMS
THE ART OF BOOKS SINCE 1949

115 West 18th Street
New York, NY 10011
www.abramsbooks.com

The following Bazooka Joe/Topps artists have been identified (numbers refer to pages): **Tom Bunk** (208), **Robert Crumb** (170–71), **Howard Cruse** (125–26, 188–96, 209), **Jay Lynch** (197, 212–14), **Wesley Morse** (i–viii, xi, 13, 18–19, 43, 58–100, 123, 130–32, 135–36, 140–41, 146–47, 150–69, 172, 178, 180–81, 224), **John Pound** (206–7), **Norm Saunders** (206), and **Craig Yoe** (198–99). As additional information becomes available leading to the identification of other artists included in this book, updates will be made in future reprints.

Unless otherwise noted below, all of the images were scanned from the collection of Jeff Shepherd.

From the Topps archives: xi, 56, 109, 133, 156 (bottom), 157 (top and bottom left), 158–60, 161 (top), 162, 164, 165 (top), 166 (top), 167, 168 (top), 169 (top), 172 (left), 176–77, 188–89, 192, 193 (top left and right), 206 (right), 208–9, 223, and rear endpaper (right).

Additional images courtesy of: Talley Morse and Nancy Morse: 13–14, 18, 47 (top), 123, 154; Kirk Taylor: 15, 45, 47 (bottom), 211, 224; Alex Winter, Hake's Americana & Collectibles (www.hakes.com): 26 (bottom), 108; *Candy Industry* magazine: 35; Mark Newgarden: 43; Chris Mosher: 46; The Taylor-Morse Collection: 48, 50–51; Jon Berk: 49; Chris Hart: 52; Richard Gelman: 54, 120 (top); Robert Lifson, Robert Edward Auctions, LLC: 57; Howard Cruse: 125–26, 190–91, 194–95; Todd Riley: 146 (left); Heritage Auctions (www.ha.com): 171; R. Sikoryak: 201–2, 205; Grant Geissman: 204; Jay Lynch: 214.

Page 204: Copyright © 1955 E.C. Publications, Inc. Used with permission.

Ancillary images: DC Comics/Fawcett Publications, Inc.: 25 (bottom), 28 (bottom right); Abbott and Costello: 30; Willard Mullin: 31 (bottom right), 32 (bottom right); Ringling Bros. and Barnum & Bailey Circus: 34–35; Carl Anderson/Henry, King Features Syndicate: 39; Al Capp/Li'l Abner, United Feature Syndicate: 103; Archie Comic Publications, Inc.: 104–6; View-Master/GAF: 110–11; Funko: 185; Erik Larsen/Savage Dragon, Image Comics: 201; Ron Barrett, Tart Graphics, Inc.: 207; Ogilvy & Mather: 211.

BAZOOKA JOE and his GANG®

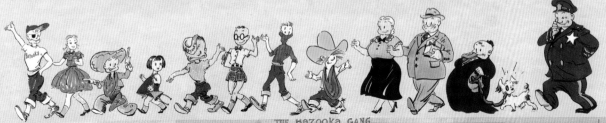

THE BAZOOKA GANG

TWO TUXEDOS AND A HOT PLATE

BY TALLEY MORSE

"Bazooka Joe's been good to us."
—WESLEY MORSE, 1961

In 1953, when Woody Gelman, head of product development at Topps, was looking for an artist to create a comic strip to wrap around their bubble gum, Mitch Diamond (a family friend from the Blackstone Agency) recommended my father, Wesley Morse, for the job as a means of drawing him out of his continuing grief over the death of my mother two years earlier. Woody was familiar with my father's comic strips from the 1920s and 1930s and his pinup art from the 1940s, and felt Dad was made for the task. Having come from the underside of the publishing business, he fit nicely within the wacky Topps machine.

For as long as I can remember, Dad's drawing board invariably bore the brunt of his cigarette habit, with burns all over it. He thought nothing of putting out his cigarette stubs in his paints or in a cup of coffee sitting nearby. One day he called me over to show off the pen-and-ink illustration he'd done of a dark-haired kid wearing jeans and a beanie, holding a baseball bat. It was the prototype of the as-yet-unnamed central character for the Topps cartoon strip. Dad knew enough about the business to know that the powers that be always have the last word. Sure enough, somewhere along the line Topps decided that the dark-haired kid should be blond, the beanie switched to a baseball cap, an eye patch added for effect, and the kid christened Bazooka Joe.

I used to race home from school to watch Dad at his drawing board, a cigarette dangling perpetually from his lips, smoke curling into his eyes as Joe, Mort, Pesty, and the other kids in the Bazooka Joe gang came to life. Dad would ask me what I thought about the latest comic strip he was working on— after all, it was for kids, and he wanted a kid's take on it—and I was always happy to oblige. I was also eager to earn my allowance by doing the four-color acetate pasteups for the printer, a job that Dad hated doing but made me feel like a part of the action.

At the time I didn't realize just how much a part of the action I really was, but I found out later that some of the antics of Joe and his gang were taken from my childhood experiences. I loved

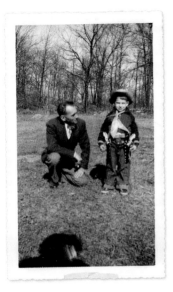

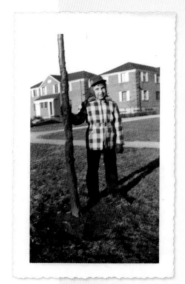

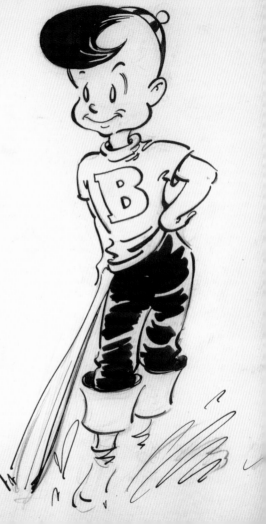

ABOVE LEFT: Wesley Morse and his son, Talley, April 1951.

ABOVE RIGHT: Talley Morse, age seven, in Bayside, New York, 1953.

RIGHT: Never-before-published initial Bazooka Joe concept drawing from 1953 by Wesley Morse, modeled after Talley. Note that Bazooka Joe has dark hair and no eye patch.

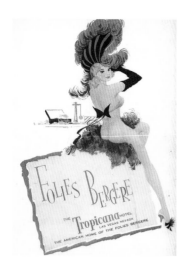

playing baseball and got into trouble whenever my ball went sailing through a window. We weren't allowed to play ball on the premises of the apartment complex where we lived in Queens, New York. The superintendent, a guy named Tom, would chase us kids away, so we'd post lookouts for him, and when he was spotted, we'd run like our pants were on fire. After work, Dad and Tom often went down to the local bar for drinks, where Tom would bemoan the latest mischief us kids had caused, and Dad would find ways to use the stories in his strips. Once, he showed me one he was working on and asked me if it looked familiar. I had recently been showing off on my bike and crashed it into a tree. Sure enough, there it was in the strip. Everything was fair game for the gang.

The *Bazooka Joe* strip wasn't my father's only creation for Topps. He also drew sixty Goofy Series Post Cards (1957) and a series of cards depicting natural disasters (although what they had to do with chewing gum and kids has always been a mystery to me), as well as an advertising campaign called "Bazooka's Out Front" that appeared in *National Candy Wholesaler* magazine (March 1957). Dad didn't shield me from much, least of all the buxom beauties he also drew. I can recall taking one look at an overly endowed lady on his drawing board and stammering something. Dad just laughed, his purpose achieved.

I was proud of my father's work for Topps, but being a kid, the thing I loved most about it was the uncut production sheets of baseball cards he brought home, especially those of my hero, New York Yankees center fielder Mickey Mantle. It was also a big deal for me to go with Dad to the Brooklyn headquarters of Topps, where he'd talk business and I'd walk out with handfuls of gum. Other times he would bring home boxes and boxes of gum and baseball cards, and I'd score points with all the kids in the neighborhood by sharing with them.

My father's career began long before Bazooka Joe and I were born. Dad glorified the American girl with illustrations of the Ziegfeld Follies' best-known beauties; penned comic strips; drew ads that ran in *Life*, *Collier's*, and *Judge*; and painted watercolor pinups that appeared in men's magazines. Stuffed into drawers and suitcases are decades of artwork, some complete, some left in progress, that chronicle

his long career. He also gave the world some notoriously sexual shenanigans in his series of Tijuana Bibles in the late 1930s, but if there were any samples of these eight-page pornographic comic books lingering around the house, I was unaware of them. There was only so much an impressionable kid was allowed to see, even by Dad's liberal standards. In fact, I wasn't even aware of those raunchy renderings until well into my adult years when writer-artist Jay Lynch told me about them.

Over the course of Dad's fifty-year freelance career, there was hardly a nightclub or restaurant in New York City whose program or menu did not feature his artwork, including the Hurricane, Cavanagh's, the Harem, the Village Barn, Basin Street East, El Morocco, Leon and Eddie's, the Cotton Club, Jack Silverman's International, Casino de Paris, and—beyond New York—the Las Vegas Tropicana.

One of the nightclubs most associated with Dad's art was the Latin

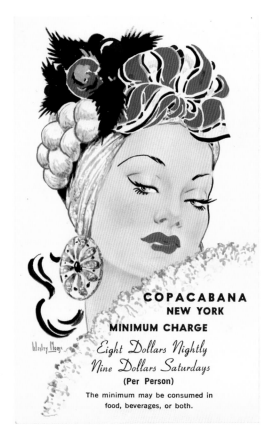

OPPOSITE: Folies Bergere program for the Tropicana Hotel, Las Vegas, Nevada, c. 1959. Nightclub impresario Lou Walters brought in Latin Quarter house artist Wesley Morse to illustrate the promotional material for his newest Parisienne extravaganza.
LEFT: Monte Proser's Copacabana promotional postcard featuring Morse's iconic Copa Girl, c. 1943.

Quarter, with its twenty-seven-girl revue, where as club illustrator, his drawings of frisky cancan dancers appeared on virtually every program and menu. I'd sometimes take the train into the city with him and we'd hop a cab to Times Square, and while Dad talked shop with owner Lou Walters ("Uncle Lou" to me), I'd watch the showgirls rehearse. I remember seeing a girl, somewhat older than myself, standing in the background, who paid no attention to a shy, awkward kid like me. I didn't realize until years later that the girl was Uncle Lou's daughter, Barbara Walters (who would grow up to become the award-winning journalist).

The other nightclub most associated with Dad was the Copacabana. The logo, created by him in 1943, of a sultry beauty wearing a bonnet of fruit, is one of the most iconic and recognizable images from that era. Dad got a good laugh that everyone thought he modeled her after the South American actress Carmen Miranda when, in fact, he didn't. Only Dad, Copa owner Monte Proser, George White (who produced the long-running Broadway revue *Scandals*), and, of course, the girl herself knew who the model really was. I wish I'd thought to ask him, but as a kid you never stop long enough to document history as it is being made.

During the 1950s and early 1960s, Dad worked tirelessly on his *Bazooka Joe* comic strips simultaneously with his Latin Quarter and other nightclub art. Although these were legitimate, well-paying jobs, on the side he drew risqué cartoons for gag digests, harking back to his vaudeville work of the 1920s and his Tijuana Bibles of the 1930s, indulging his own prurient interests and delighting in giving everyone a good, hearty laugh. Dad left an indelible mark, building a reputation on Broadway and making connections from which I benefited. It was a thrill for me, as a teenager, to get in free and unescorted to places like Basin Street East to hear Peggy Lee, and the Metropole to see my music idol, drummer Gene Krupa.

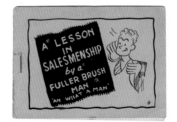
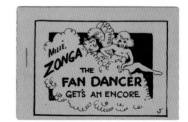

ABOVE AND OPPOSITE: Covers from Wesley Morse Tijuana Bibles, c. 1939.

It always amazed me that a soft-spoken, self-effacing guy like my father counted among his friends the famous and the infamous—like the actors George Raft and William Demarest, and cartoonist Chic Young. One enduring friendship was with boxing champ Barney Ross ("Uncle Barney"—I had a lot of uncles in those days), who, like Dad, had grown up on the streets of Chicago.

I loved listening to Dad's stories about the Jazz Age. He often said that all he needed in those days were two tuxedos and a hot plate. He'd work in his studio all day and then at night get decked out in one of his tuxedos and head downtown to sip bootleg whiskey with Legs Diamond or stay uptown to trade gossip at the Stork Club with columnist Walter Winchell.

Dad liked to boast that back in those early Broadway days he was quite the ladies' man. Yet despite having dated women like Ruby Keeler and Barbara Stanwyck (both of whom went on to become movie stars), and countless showgirls who never went beyond the speakeasy floor shows, he often told me that the only woman he ever really loved and wanted to marry was my mother. She was everything he was looking for—neither a showgirl nor a budding movie star, but a businesswoman with a wicked sense of humor to match his own.

From his bawdy cartoon strips and half-clad beauties of the 1920s to his scandalous depictions of the 1939 World's Fair in his series of Tijuana Bibles and the legitimate nightclub art of the 1940s and 1950s, Dad is perhaps best known for the Topps strip. From the e-mail I receive from fans around the world, the name Wesley Morse is synonymous with that of *Bazooka Joe*. He drew the strip from its debut in 1954 until the early 1960s, when his lifelong cigarette habit finally caught up with him and he became too ill to work. Although the characterizations of *Bazooka Joe* have changed in the years following his death, the most memorable and

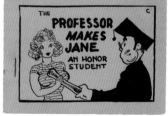

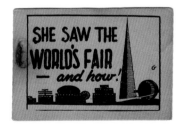

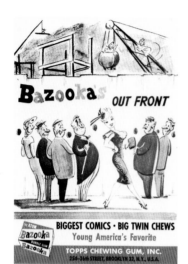

ABOVE: "Bazooka's Out Front."
Advertisement by Wesley Morse for
National Candy Wholesaler, March 1957.
OPPOSITE: Wesley Morse–illustrated Topps
company letterhead, c.1957

sought-after gang is the one created
by my father and featured in this book.
It's ironic, since he almost didn't take
the job.

When Woody Gelman made the
offer, Dad wasn't sure he wanted to
do it, so he asked me for my advice. I
told him I thought it was a good idea.
Imagine a grown man asking a kid for
advice. But Dad was like that, often
deferring to me on decisions. Despite his
worldly experiences, he was very much
a kid at heart. He had lost the love of his
life (Mom passed away in 1951 when I
was five) and needed a little guidance,
even if it came from a seven-year-old.
Ten years later, shortly before he died,
Dad told me that Bazooka Joe had been
good to us.

When I was asked to write this
essay on my personal connection to
Bazooka Joe, it brought back poignant
memories for me of the postwar years,
when people were putting their lives
back together; kids were taking cover
under school desks during practice

air-raid drills; the first satellites were
launched; a Catholic was elected
president; there were three baseball
teams in New York; Mickey Mantle and
Roger Maris ran a home-run race and
Maris broke Babe Ruth's record; and
Jonas Salk invented the polio vaccine.
Life was on the move and changing fast.
Through it all, the connecting thread,
the one constant for me, was Bazooka
Joe. My life was indelibly entwined with
his. Like kids everywhere who played
baseball, built tree houses, pulled pranks,
and got into trouble, I was Joe. Only
more so than other kids, because in my
private collection of my dad's artwork
spanning five decades is that pen-and-
ink drawing of the dark-haired kid. The
one and only illustration of the original
Bazooka Joe. It has been said that the
character of Joe was modeled after the
founder of Topps, Joe Shorin, but what
only Dad and I and a few close friends
knew was that the first depiction of Joe,
the one Dad preferred, was modeled
after me when I was seven years old.

My wife, Nancy, likes to joke that she's married to the original Bazooka Joe, and I guess you could say that's true.

I've heard my father referred to as the J. D. Salinger of illustration because so little is known about him. But that's because he was a suave, generous, reticent man who let his art do the talking for him. The information and personal recollections contained in this book are just a brief glimpse into a life that was much more colorful, and his portfolio of art much more extensive than what you read and see here. Interestingly, today, fifty years after his death, his artwork keeps turning up on the Internet. And even those pieces that sell at auction and on eBay are only the tip of the iceberg of his prodigious body of work.

This book could not have been possible without the efforts of many. I would like to thank Mitch Diamond, who cared enough for my father to find a way to draw him out of his grief; Woody Gelman, who believed in Dad's talent and became a good friend over the years and will be forever remembered as a kind and generous man; Charles Kochman, the editor whose perseverance in bringing this book to publication over a period of four years shines a much-deserved light on *Bazooka Joe* and my father; Kirk Taylor, whose boundless enthusiasm has led to the discovery of some of my father's artwork I never knew existed; and my wife, Nancy, who helped me put my scrambled memories of *Bazooka Joe* and my father into words.

For readers who were a part of my father's era, I hope this book brings back some fond memories of childhood. For younger readers, I hope this gives you a glimpse into a less complicated time. Sixty years later, I am pleased to finally reveal the story of how a drawing of a kid from Queens morphed into an international icon.

TALLEY MORSE grew up surrounded by his father's artwork. Many of the *Bazooka Joe* strips were influenced by Talley's childhood antics. Now retired, for many years he was a musician and worked in the film industry on major motion pictures and numerous television series. He lives with his wife, Nancy, in South Florida.

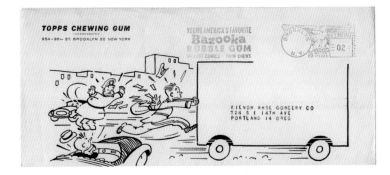

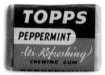

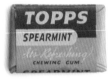

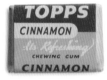

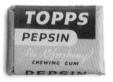

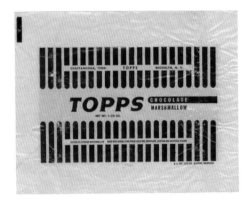

TOPPS CHEWING GUM

INCORPORATED

60 BROADWAY, BROOKLYN, N.Y. TELEPHONE EVERGREEN 8-8585

OPPOSITE LEFT: Beginning in December 1938, Topps released a one-cent chewing gum in four flavors: peppermint, spearmint, cinnamon, and pepsin. Referred to as the "changemaker" in period advertising, store patrons were encouraged to take their change in Topps gum, usually located next to the register in cylindrical cardboard containers. Packaging carried the slogan "Don't Talk Chum . . . Chew Topps Gum" throughout World War II as a patriotic reminder to curtail careless talk. The ginger flavor appears to have been replaced early on in production with pepsin.

OPPOSITE RIGHT: Topps also experimented with the release of several short-lived candy bars during the war. Mairzy and Topps Chocolate and Marshmallow (aka Topps Opera Bar) were solely manufactured in Chattanooga, Tennessee, and may have been the result of sugar rationing.

ABOVE: Topps Chewing Gum Incorporated company letterhead, 1940. The original headquarters were located in the Williamsburg neighborhood of Brooklyn, in the Gretsch Building, where musical instruments were manufactured.

RIGHT: Trade article, September 1947.

TOPPS ENTERS BUBBLE GUM FIELD

The Topps Chewing Gum, Inc., Brooklyn, N. Y., has entered the bubble gum field with "Bazooka, the Atom Bubble Gum," according to an announcement by Joseph E. Shorin, president of the firm. The piece will retail at five cents and consists of six sections of bubble gum in a red, blue and silver wrapper.

The new product will be made by Bubbles, Inc., newly formed subsidiary of the Topps firm.

Each Bazooka package will obtain a miniature comic strip to give further appeal to the youngster trade. Premiums are also being used as a sales aid for both consumers and retailers.

Bazooka carries the seal of approval of Parents' Magazine, according to the company.

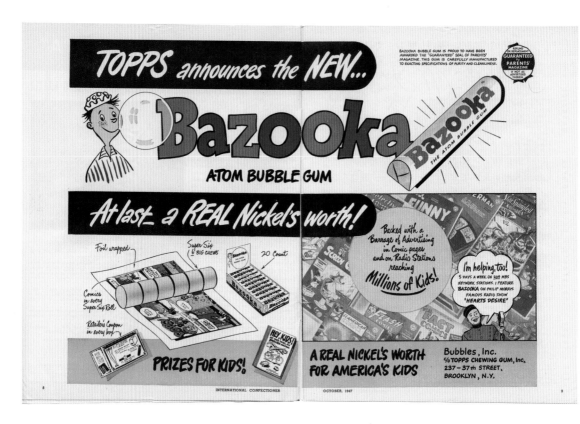

ABOVE: Two-page trade ad introducing Bazooka gum, October 1947.
OPPOSITE: Window decal, late 1940s.

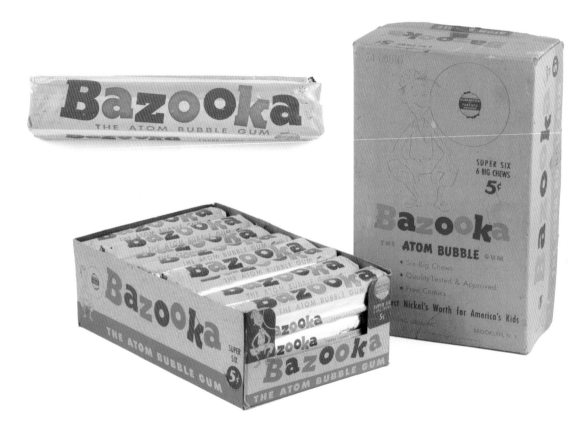

A complete box of five-cent Bazooka bubble gum, 1947.

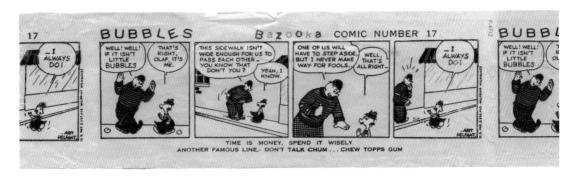

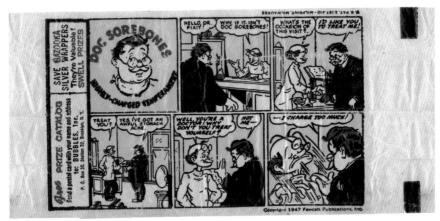

The first comics inserted in Bazooka gum: *Bubbles*, illustrated by Art Helfant, and *Doc Sorebones* (licensed from Fawcett Publications, Inc.), 1947.

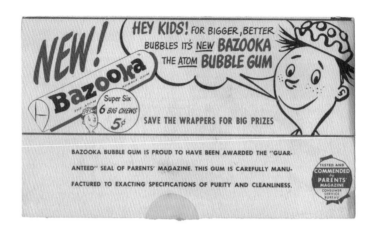

TOP: The first Bazooka prize catalog cover, 1947.

BOTTOM: The earliest known reference to Bazooka Joe, printed on a postcard explaining that the first prize catalog had run out. Hand dated October 20, 1947, fifteen thousand copies were printed.

OPPOSITE LEFT: Sell sheet distributed to candy jobbers to advertise product and current prices, July 1948.

RIGHT: Comic book ad featuring Bazooka the Atom Bubble Boy, 1948.

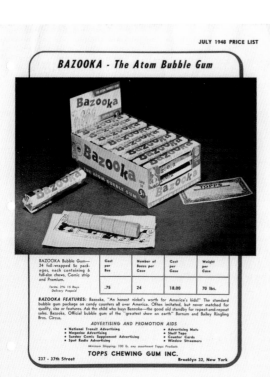

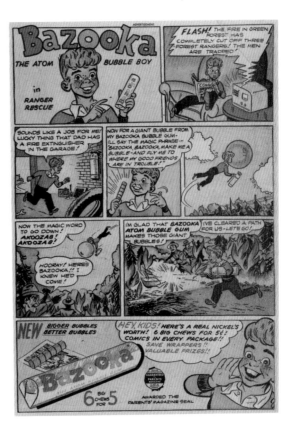

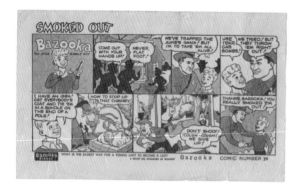

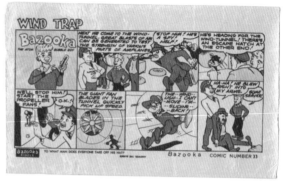

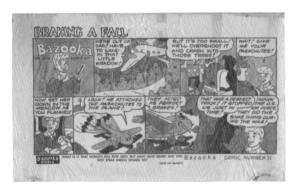

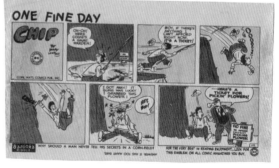

ABOVE: Gum comics found on the reverse of five-cent Bazooka foil wrappers, 1948–49. *Bazooka the Atom Bubble Boy* (top row and bottom left) and *Chip* (bottom right) by Harry Lampert (licensed from DC Comics).

OPPOSITE: Inner wax premium wrappers, 1948. Found inside packs of five-cent Bazooka, these wrappers served a dual purpose of protecting the comics from the gum and advertising mail-order premiums for kids.

real handy gadget for emergency coins.
Send only 3 Bazooka Silver Wrappers
and 15c to: Bazooka Box 84,
New York 8, N. Y.

(Not valid where contrary to state laws.)

WOW!! DID YOU SEE THIS *MEXICAN COIN BRACELET*? IT HAS REAL COINS!

No. 105 MEXICAN COIN BRACELET

Four genuine copper Mexican coins
attached to a chain with a safety
clasp. The smartest jewelry value
you've ever seen. Regular $1
value. Only 3 Bazooka Silver
Wrappers and 25c. Send to:
Bazooka, Box 84, New York 8, N. Y.

(Not valid where contrary to state laws.)

THIS *KEY CHAIN* IS REALLY HEP!

No. 107 ADJUSTABLE POCKET KEY CHAIN

A gold-color key chain. Clip lets
chain hang from belt while keys
are In pocket. Send only 3
Bazooka Silver Wrappers and 10c to:
Bazooka, Box 84, New York 8, N. Y.

(Not valid where contrary to state laws.)

BOYOBOY!! I JUST GOT MY NIFTY FELT *SWEATER LETTERS!* THEY'RE JUST PERFECT FOR YOUR ATHLETIC DUDS!

No. 111 SWEATER LETTERS

Choice of big felt letters or numerals in
any color. Press on with hot iron.
Mention letters and colors you want.
Send only 1 Bazooka Silver Wrapper and 10c for each
letter to Bazooka, Box 20, Madison Sq. Station, New
York, N.Y. Free Bazooka prize catalogue with each order.

(Not valid where contrary to state laws.)

FELLERS!! THIS *PERFUMED NECKLACE* IS JUST THE THING FOR YOUR BEST GAL!!

No. 108 PERFUMED NECKLACE

Fine, filigree pendant. Renew
with your own perfume. Gold
plate chain with clasp. Send only
3 Bazooka Silver Wrappers and
25c to: Bazooka, Box 84,
New York 8, N. Y.

(Not valid where contrary to state laws.)

BLOW ME DOWN IF THIS *WOLF WHISTLE* ISN'T TERRIFIC.'

No. 113 WOLF WHISTLE

#127 MAGIC QUIZ PICTURES

20 Magic Pictures — Complete with Mystery
Developing Paper. Movie Stars, Westerns, etc.
Send either one FLIP-O-VISION wrap-
per of BAZOOKA, America's finest Bubble Gum to-
gether with 10c to: Bazooka, Box 100, Brooklyn 32,
N. Y.

(Not valid where contrary to state laws.)

#126 SECRET CODE SET

Big 8 piece set. Make secret notes that only you and
your pals can read. Send only 1 FLIP-O-VISION Wrap-
per or 1 Wrapper from BAZOOKA, America's Finest
Bubble Gum, together with 25c to: Bazooka, Box 20,
Madison Sq. Station, New York 10, N. Y.

(Not valid where contrary to state laws.)

BOYOBOY!! I JUST GOT MY NIFTY FELT *SWEATER LETTERS!* THEY'RE JUST PERFECT FOR YOUR ATHLETIC DUDS!

#111 SWEATER LETTERS

Choice of big felt letters or numerals in any color. Press
on with hot iron. Mention letters and colors you want.
Send either one FLIP-O-VISION Wrapper or 1 Wrapper
of BAZOOKA, America's Finest Bubble Gum, together
with 10c to: Bazooka, Box 20, Madison Square Station,
New York 10, N. Y.

(Not valid where contrary to state laws.)

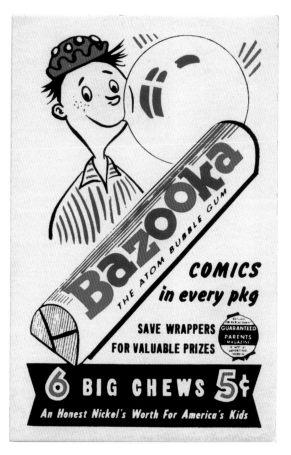

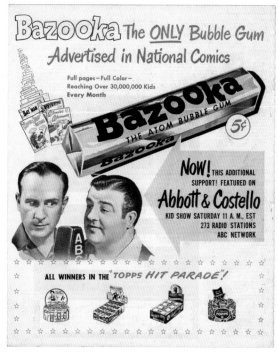

LEFT: Cardboard advertising standee, c.1949.
RIGHT: Abbott and Costello Bazooka trade ad from March 15, 1949, featuring all available Topps products on the bottom.

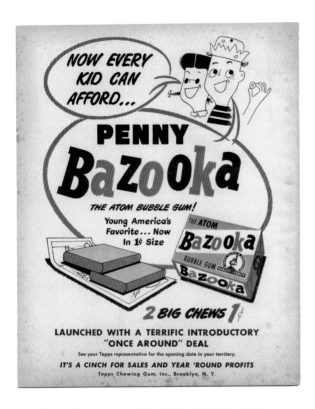

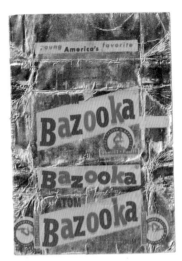

LEFT: Trade ad introducing one-cent Bazooka, October 28, 1949.
RIGHT: Bazooka one-cent foil wrapper with a Willard Mullin sports
comic on the reverse, c. 1949.

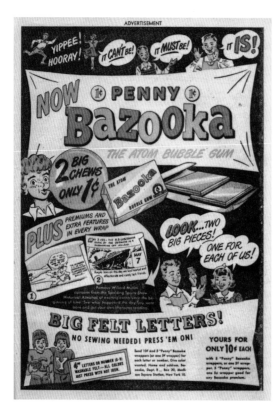

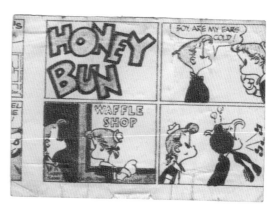

LEFT: Penny Bazooka comic book ad, 1949.
RIGHT: *Honey Bun* by Hal Rasmusson (top) and Willard Mullin (bottom) gum comics found on the reverse of one-cent Bazooka foil wrappers, c.1949.

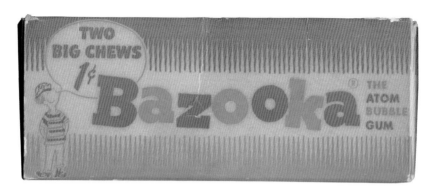

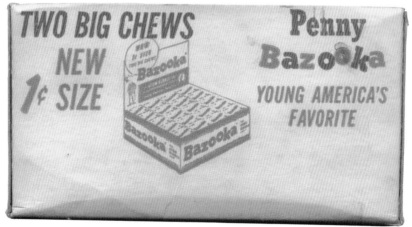

Front and back panels of a one-cent Bazooka store display box, 1949.

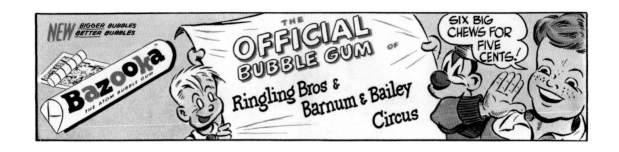

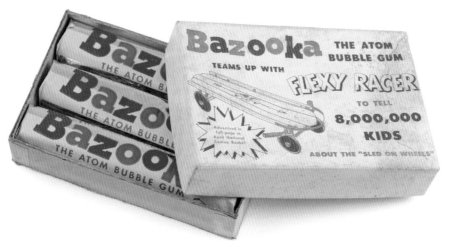

TOP: Ad from Ringling Bros. and Barnum & Bailey Circus program, 1949.

BOTTOM: Bazooka Flexy Racer promotional box given to jobbers and store owners, c.1949.

OPPOSITE LEFT: Ringling Bros. and Barnum & Bailey Circus comic book ad, July 1949.

OPPOSITE RIGHT: Trade article from *Candy Industry* magazine, July 5, 1949.

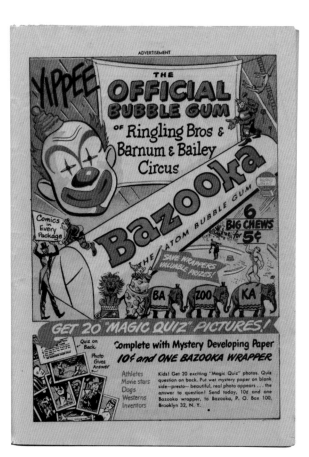

Greatest Bubble on Earth!

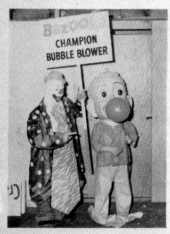

The house lights dim, the curtain parts and the ringmaster announces "Bazooka — Champion Bubble Blower." At every performance of the Ringling Bros. & Barnum & Bailey Circus — which has named Bazooka, manufactured by Topps Chewing Gum, Inc., as "The Official Bubble Gum of the Circus" for 1949 — a clown with a large head, shown above, will circle the arena blowing and retracting a gigantic bubble for the amusement of kids from coast to coast.

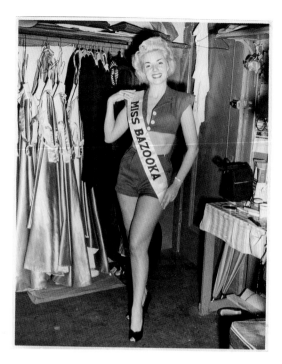

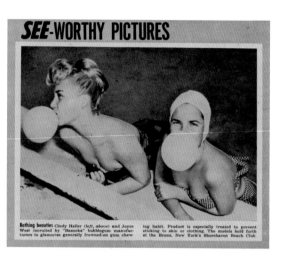

Bathing beauties Cindy Heller (*left, above*) and Joyce West recruited by "Bazooka" bubblegum manufacturers to glamorize generally frowned-on gum chewing habit. Product is especially treated to prevent sticking to skin or clothing. The models hold forth at the Bronx, New York's Shorehaven Beach Club

NEW BAZOOKA QUEEN

Gregg (Sherwood,) showgal featured in musical smash, "As The Girls Go", proudly displays her new title, "Miss Bazooka of 1949" conferred on her by Bubble Gum Chewers of America. Here's Gregg backstage in her dressing room at Winter Garden where show is playing. 12/3/48

LEFT: Wire press photo of Gregg Sherwood, Miss Bazooka 1949—a promotion that ran for several years.
TOP RIGHT: Models hired by Topps to promote Bazooka, January 1950.
BOTTOM RIGHT: Description from the back of a Miss Bazooka wire photo, hand dated December 3, 1948.
OPPOSITE: Official League Baseball comic book ad, July 1950.

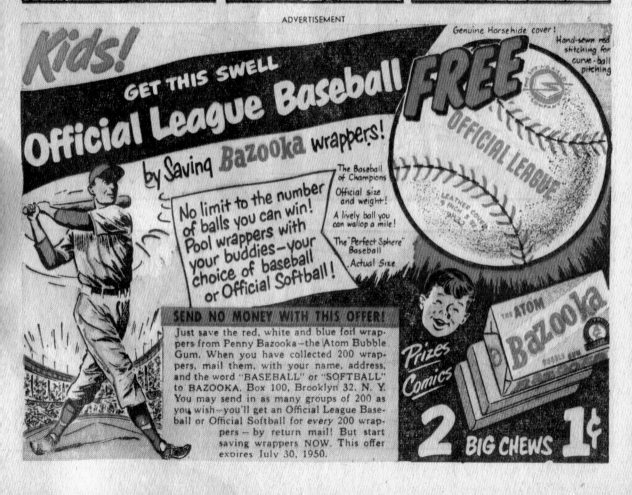

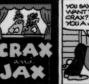
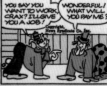

Topps released a variety of gum comics leading up to the release of *Bazooka Joe*, experimenting with licensed characters and creations of their own. The comics on these two pages and the following page were printed on wax paper and issued with one-cent Bazooka.

OPPOSITE: Gum comics *Crax and Jax* by Howard Sparber and *Honey Bun* by Hal Rasmusson (licensed from News Syndicate Co., Inc.), c. 1951–52.
ABOVE: *Henry* gum comics by Carl Anderson, 1953–54.

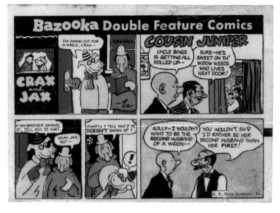

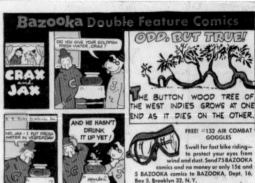

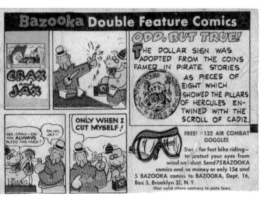

OPPOSITE: Bazooka Double Feature Comics starring *Crax and Jax* by Howard Sparber, 1954. This was the last set of comics issued prior to the launch of *Bazooka Joe*.
ABOVE: Bazooka bubble gum box panel, 1950s.

BEHIND THE EYE PATCH

THE ANONYMOUS LEGACY OF WESLEY MORSE

BY NANCY MORSE AND KIRK TAYLOR

"You've got a real story to tell on the BAZOOKA COMICS so don't miss an opportunity to TELL IT!"
—SY BERGER, TOPPS EXECUTIVE, FROM A SALESMAN'S SAMPLE FOLDER, 1957

You could say that for Wesley Morse, born in 1897, bubble gum was practically a birthright. By then the gum industry was beginning to reach a wider public, and chewing gum was well on its way to becoming a national pastime. In 1888, the first vending machines designed to distribute gum were installed in New York City subways. In 1890, Morris Shorin started a company that would one day innovate the gum business. Taking advantage of the vast distribution network already established, Shorin's heirs would later reinvent bubble gum. Meanwhile, in 1906, the first true bubble-blowing formulation was introduced, but nine-year-old Morse was too preoccupied with being a kid, running through Chicago's back alleys with his gang, and had no way of knowing the impact this pink latex confection, or a certain corporation, would have on him later in life.

An artistic career, which decades later produced not one but two internationally recognized advertising icons, began inauspiciously at age thirteen with Morse sketching the horses that pulled the grocery wagon he drove. Five years later, hoping to make a name for himself with his art, he headed for New York City, where opportunities for his burgeoning talent lay everywhere. At the cusp of the most exciting time of his life, the world erupted into war, and his artistic career was put on hold when, in 1917, he enlisted in the army and spent the next year in the trenches in Europe.

When Morse returned from the Great War in 1918, New York City was teetering on the brink of the Jazz Age. Serving in France during World War I exposed him to a much more modernistic and sexually liberated mind-set. Morse arrived on the Great White Way with a new sensibility that would contribute to the transformation of the cultural landscape, pushing it with enough steam to carry through the next five decades and beyond.

His knack for capturing the female

form brought him into the employ of the great showbiz impresario, Florenz Ziegfeld. Although the exact date Morse began his tenure with the Follies is uncertain, we do know that in 1922 he was illustrating Ziegfeld's beauties while residing in a studio at the Hotel Des Artistes, an artist cooperative on West 67th Street off Central Park. The hotel was to the visual arts what the Algonquin was to the literary circle of the day, and had become the epicenter of the impulse toward "Glorifying the American Girl," a phrase coined by Ziegfeld and used in the promotion of the 1923 edition of the Follies. The phrase, now synonymous with the Follies, wasn't simply sensationalism. It was a mantra—a mission statement— one its performers, writers, artists, and everyone working for Ziegfeld was held to with exacting standards.

Bazooka Joe character portrait by Wesley Morse. Pencil, ink, and gouache on board, c. 1954.

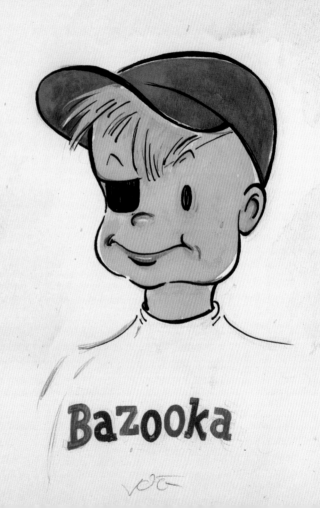

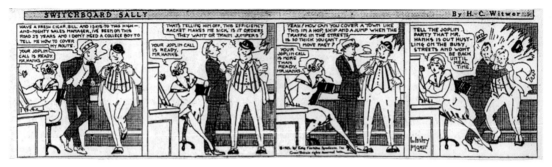

"Switchboard Sally" daily newspaper strip by H. C. Witwer and illustrated by Wesley Morse, July 11, 1925.

In 1923, Morse's drawings of chorus girls were prominently displayed in the lobby of the New Amsterdam Theatre, home of the Follies, in place of those done by Raphael Kirchner, who had been a Ziegfeld illustrator prior to his death in 1917. Morse was undoubtedly familiar with Kirchner and may well have been influenced by his risqué contributions to magazines like *La vie Parisienne* while Morse was stationed in France during the war. There can be no doubt about the impact

working with the Ziegfeld Follies had on young Morse's career, influencing his artistic perception and paving the way for many lifelong friendships and showbiz associations.

It was during this time that Morse met rising star Avonne Taylor, who became his Jazz Age muse. Then a chorus girl appearing in multiple editions of the Follies and the stage musicals *Sally* and *Kid Boots,* Ziegfeld proclaimed Taylor the "Prettiest Girl of the Follies of 1922." It was a tagline that captioned a pastel portrait of Taylor on the cover of *Judge*, a college humor magazine that Morse also drew one-page gags for. The bit

of ballyhoo surrounding the description most likely came from the faithful pens of Ziegfeld's press agents, but it was no less true, because the Follies were an illusion that Ziegfeld sold better than anyone, and Morse penned to perfection.

During his year-long romance with Taylor, Morse drew a series of illustrated love letters of and for Avonne. Unseen for more than seventy years, they were discovered in a storage locker after Taylor's death and have been compiled into the Taylor-Morse Collection. The self-portrait appearing on page 48, depicting twenty-five-year-old Morse sitting at an easel laconically eyeing a

work in progress, and those on pages 50 and 51 (published here for the first time), are three of many in the collection, and among the few known self-portraits of Morse to exist. Done on his personal Hotel Des Artistes stationery, they serve as a window into a poignant yet passing moment in the lives of two young people who helped define the times. The spirit of this lively age is captured in pen and ink by an artist developing the very technique that would carry him through the ensuing decades to the creation, thirty years later, for which he would be most remembered.

The earliest evidence of Morse's connection to the world of cartooning can be found in these illustrations. Many of the drawings are captioned "Bughouse Fables," a clear reference to the then-popular gag panel strip by Chicago cartoonist Billy DeBeck. DeBeck's *Bughouse Fables* comic strip depicted everyday folks in absurd situations, and

Grape-Nuts advertisement by Wesley Morse, *Collier's*, July 2, 1932.

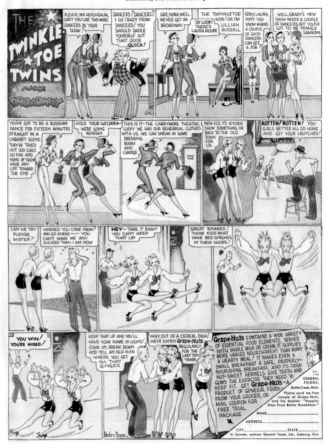

Morse used it as a gag line in several of the drawings depicting Taylor and himself engaged in ribald hijinks. In these drawings the girl is clearly not the weaker sex. She represents the liberated woman of the 1920s—the flapper who was not timid about doing things her own way. Whether aware of it or not, Morse illustrated the shift in mores from the pervading standards of the previous generation to women's new-found independence that brought, among other things, the freedom to wear revealing clothes and sometimes no clothes at all, as Morse so engagingly documented.

With his work at the Follies winding down, the associations he made influenced the new opportunities that presented themselves. Likely benefiting from the close relationship Flo Ziegfeld had with newspaper publisher William Randolph Hearst, Morse was given the opportunity to take his first stab at the funny pages with the comic strip *Kitty of the Chorus*, a perfect specimen of the then ubiquitous "flapper" strip. Kitty made her debut in 1925 on the front page of Hearst's newly published tabloid, the *Daily Mirror*. When Kitty's time in the spotlight faded, another gal stepped in.

Switchboard Sally was penned by slanguist H. C. Witwer. Sally bears a

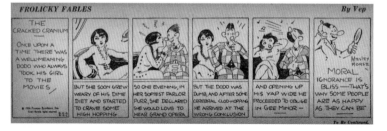

LEFT: *Frolicky Fables* by Víctor Estenio Pazmiño (Vep), illustrated by Wesley Morse for the Premier Syndicate, February 3, 1926 (top) and, February 22, 1926 (bottom).

OPPOSITE TOP: *Beau Gus* header, 1933. Prior to its publication in 1938 in the anthology comic book *Circus: The Comic Riot*, Morse's *Beau Gus* was being developed with writer Bud Wiley as a four-panel strip awaiting syndication. This header was never published.

OPPOSITE BOTTOM: *Kitty of the Chorus* by Wesley Morse, March 23, 1925.

striking resemblance to the depictions of Avonne Taylor found in Morse's illustrations of her. Teaming with Witwer to create the strip, Morse was dubbed by Witwer "the greatest pretty-girl-artist on Broadway" for his work with the Follies. Following on the high heels of *Sally* came *May and June*, a strip about a blonde and a brunette, for the notorious tabloid the *New York Evening Graphic*, brainchild of pulp magazine publisher and health guru Bernarr "Body Love" Macfadden.

Another early comics association was with Victor "Vep" Pazmino, with whom Morse teamed to produce the short-lived *Frolicky Fables*. Distributed by the Premier Syndicate, Hearst's second-stringer imprint, from 1925–26, the strip, drawn by Morse and scripted by Vep, reads like a Jazz Age take on Aesop.

Morse was slowly whittling his way to a more cohesive style, ink slash by ink slash, developing the comical male character types that gave the early strips an odd duality, and carving out a comic strip style all his own—a style so distinct

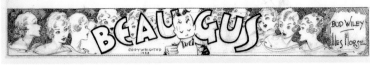

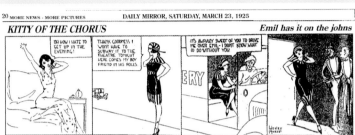

that even anonymity could not keep his authorship hidden from history.

During this period, Morse shared a studio in New York City with Murat Bernard Young, better known as Chic Young. Their career paths were forever forged at this time, creating comic strip characters that are widely known and loved—whereas Young's fame came from writing and illustrating *Blondie*, starting in 1930, Morse's would come more than two decades later, albeit anonymously, working on *Bazooka Joe*.

As the decade was drawing to a close, Morse's glorification of the American girl took on a new dimension. In 1927, he illustrated a series of ads for Golden Glint Shampoo that appeared in *Life*. These ads are fine examples of his early hand in the ad game, and the beginning of the burgeoning cosmetics and beauty product boom. The 1930s saw a change in the methods used by companies to reach American consumers suffering under the economic downturn of the Great Depression. In 1932, the

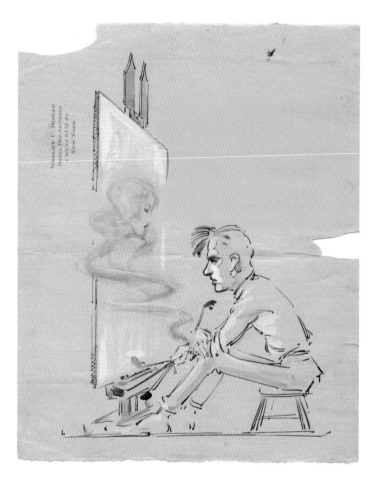

advertising firm of Young & Rubicam created a series of comic strip ads for Grape-Nuts cereal, which wrapped the product in an engaging story and helped lead the way toward deepening brand loyalty. When William Randolph Hearst, one of Morse's former employers, opened up the comics section of his newspaper empire to advertisers, it increased the reach of the advertisers and brought their products into homes all across America. Morse's contribution to the innovative campaign was a rags-to-riches full-page comic featuring mirror-image chorines, *The Twinkle Toe Twins*, whose boundless energy was supplied by the bowls of Grape-Nuts cereal they consumed.

With the repeal of Prohibition and the arrival on the scene of a new generation of nightclub owners, the speakeasies Morse had frequented gave way to more fashionable venues like the French Casino; the El Morocco; a little club owned by Billy Rose called Casino de Paris; and the Stork Club, where he traded Broadway rumors with gossip-columnist-

in-residence Walter Winchell, an old friend from the *Daily Mirror* and the *Graphic*.

Around this time, comics already in syndication were anthologized into book form. One example was *Famous Funnies*, with the cover art often by Victor Pazmino, Morse's partner on *Frolicky Fables*. With publishers competing to come up with the next hot-selling character, in 1938 publisher Monte Bourjaily compiled original material, and the Globe Syndicate published *Circus: The Comic Riot*. An early "comic book" anthology of strips in development that were waiting for syndication, Morse's *Beau Gus* shared the pages with those of such comics luminaries as Jack Cole, Basil Wolverton, Bob Kane, and Will Eisner.

Despite an ever-evolving portfolio of work, the one thing that never changed was Morse's bawdy sense of humor. In 1939, he penned some of the notorious Tijuana Bibles, a series of eight-page erotic comics pamphlets, many of which centered around his characters' naughty escapades at the World's Fair. Of only two known authors to have been identified by today's comics historians, Morse's distinctive scrolling calligraphic line belies his hand. He was perfectly suited to the work, having come out of the era of the speakeasy and unsigned contracts sealed with a handshake. It was illicit, but it was paying work, and that was fine with Morse. His gift for satire and vaudevillian humor runs rampant in the pages of his Bibles. It is in these proto-underground comics pamphlets that he arrived at the style we most associate with him today. One cannot help but wonder if, while producing these infamous Tijuana Bibles, he was even aware that a certain chewing gum company had recently come into existence.

One name Morse would later be connected to also had a stake in the 1939 World's Fair. Monte Proser, later known as the owner of the Copacabana nightclub, opened the Zombie Room at the Fair, naming the club after the potent drink he claimed to have invented. Morse depicted Proser's Zombie Room in one of his World's Fair Bibles, unaware that

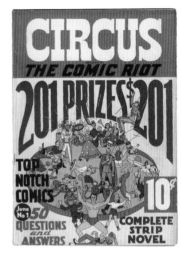

OPPOSITE: Wesley Morse self-portrait from a letter to Ziegfeld Follies dancer Avonne Taylor, c. 1922–23.

ABOVE: *Circus: The Comic Riot* no. 1 by Globe Syndicate, June 1938.

OVERLEAF: "Bughouse Fables" by Wesley Morse. Pencil, pen, ink, and gouache on stationery, c. 1922–23.

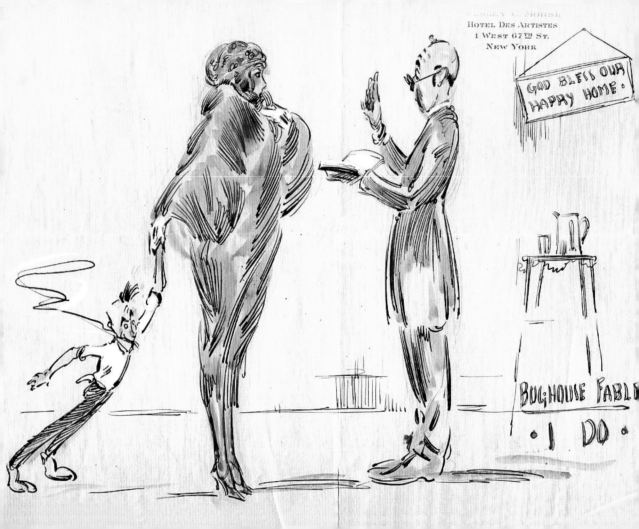

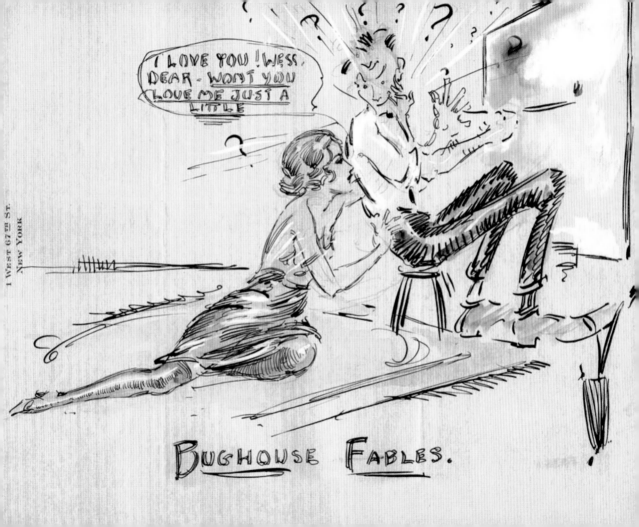

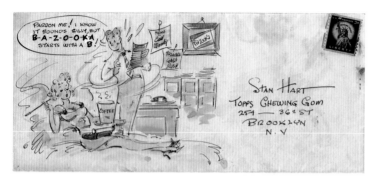

Wesley Morse–illustrated envelope addressed to Stan Hart, humorist and gag writer at Topps, c. 1955–58.

during the next decade his cartoon gals would pop up all over Proser's famous Beachcomber restaurant menus and lead to one of Morse's most indelible nightclub icons.

By the time the 1930s rolled to a close, Morse had produced some of the decade's most recognizable and distinctive promotional art, and the theater connections he made during that period led to his becoming the preeminent illustrator of the nightclub era. The new decade legitimized Morse's anonymous

underground work, bringing the recognition he deserved when he found himself freelancing for another Broadway impresario. This time it was Lou Walters, owner of the flamboyant Latin Quarter. As club illustrator, Morse's drawings of Walters's handpicked showgirls appeared in virtually every program and menu, giving the Latin Quarter its Gay Paree flair. And then there was the Copacabana. Hired in 1943 by Copa owner Monte Proser to give the club a Brazilian flavor, the logo created by Morse of a sultry

beauty beneath a colorful bonnet of fruit has become the most recognized logo of the nightclub era—its Mona Lisa.

But the decade brought more than artistic acknowledgment; it brought Lucy Anne Olsen. At the age of forty-five, Wesley Morse finally found the woman he wanted to marry, and in 1944 he gave up his bachelor status in favor of wedded bliss. Two years later a son, Talley, was born. Coincidentally, a year after that, Topps gave birth to its own bundle of joy, Bazooka bubble gum. Little could Morse have known then how his path would intersect with that of Topps.

The man-about-town-turned-family-man continued to work for Lou Walters's Latin Quarter while illustrating menus and programs for many of New York City's best-known restaurants and nightclubs, as well as painting watercolor beauties and magazine covers. Never one to shy away from the risqué, Morse continued to take jobs on the fringes, providing content for cheaply printed gag digests produced by underground publishers in Times Square.

In the 1950s, a climate of repression was on the rise in America. For cartoonists like Morse, the Comics Code Authority had a resounding effect. Created to restrict the type of lurid and often violent material portrayed in comic books, the CCA forced comics companies, artists, and writers out of business. Around this time, Woody Gelman and Topps were looking for an artist to reinvent the comics they wrapped around Bazooka bubble gum. Gelman knew of Morse's work on those free-expression-of-ideas pamphlets, the Tijuana Bibles, but was such a fan of the art that he didn't mind the content. His choice of Morse to create a pop poster child for the booming youth culture was based on Morse's multifaceted output. Little could anyone know that concealed around a hunk of pink bubble gum, within the innocuous wax paper wrapper, was a comic strip authored by one of the art form's most subversive and enigmatic figures.

Everything Morse did up until that point paved the way for the distinctive style that gave *Bazooka Joe and His Gang* its appeal. His glorification of the Ziegfeld girl, the comic strips for Hearst, the bawdy comedy of the vaudeville stage, the pinup art, the pioneering work in the early comics of the 1930s, and the nightclub art of the 1940s were all grist for the *Bazooka Joe* mill. Combined with antics drawn from his son's life, the "gang" Morse created with Woody Gelman has become internationally known, and is a fitting legacy for a man who worked anonymously for most of his career. Morse drew the strip throughout the last decade of his life until shortly before his death in 1963, and enjoyed every minute.

From the Great War to the Great White Way, through the darkest days of the Great Depression, through the coming of the Second World War and into the boom times of the postwar era, Wesley Morse left a lasting impression on the richly varied landscape that is American popular culture. The artist who gave the world the international icon known as Bazooka Joe, although still cloaked in mystery, is now no longer anonymous.

NANCY MORSE is an award-winning author of seventeen historical and contemporary novels, with titles that include *Silver Lady* (1980), *Where the Wild Wind Blows* (2011), and her latest, *This Child Is Mine* (2012). Her books have been published by Simon & Schuster, Dell, Meteor, and Silhouette, and she has also published independently. She is an assistant editor for the newsletter of a political party in Palm Beach County, and editor of *Paw Prints*, a community newsletter for dog lovers. Nancy and Kirk Taylor are currently working on a book about the life and art of Wesley Morse.

KIRK TAYLOR is the curator of the Taylor-Morse Collection, and the great nephew of Avonne Taylor. As an artist and writer, he has had a lifelong passion for comics and their creators, has owned and operated an art gallery, and over the years has exhibited his own work. Recognizing the potential importance of the Taylor-Morse drawings, Kirk carried them with him for over fifteen years before discovering their true significance and beginning the process of bringing them wider recognition. Kirk lives with his wife, Amanda, in the historic German Village of Columbus, Ohio.

WOODY GELMAN
AND THE BAZOOKA JOE STORY

BY LEN BROWN

Woody Gelman in 1954, in front of his collection of dime novels from the early 1900s.

If you had read and collected *Bazooka Joe* comics during the last sixty years, you might have wondered who was behind creating the quirky-looking characters that populated Joe's universe. Generations of kids have been Bazooka gum chewers, enjoying its flavor, blowing bubbles, and saving the interior comics for "valuable prizes." The *Bazooka Joe* creators have remained largely anonymous over the years, but it's high time that credit is given to the men who played the largest part in the development, the design, and the execution of this American icon during his formative years. I would go as far as to say that Woody Gelman was the closest to a real father that Bazooka Joe ever had.

Woody began his career in animation, moving from Brooklyn to Miami, where Paramount Pictures had a thriving studio in the 1930s. It was there that Woody met Ben Solomon, another animator, and the two men became lifelong friends. Together they were part of a team who worked on early Popeye cartoons, *Gulliver's Travels* (only the second full-length animated feature produced), and then the much-loved Max Fleischer Superman animated shorts of the early 1940s.

Eventually Woody became involved in an attempt to unionize the animators, and when Parmount found out about his activities, he was promptly fired.

Gelman returned to the New York area and began writing and creating

stories for DC Comics. Two of his creations, *The Dodo and the Frog*, and *Nutsy Squirrel*, appeared regularly in two funny-animal comic books, *Funny Stuff* and *Comic Cavalcade*.

When Paramount Studios shut down their Florida facility in 1945, Ben Solomon reunited with Woody and the two partnered in an art studio, creating ads and packaging for their clients. One of their first customers was the Joe Lowe Company, who manufactured Popsicle ice pops, a popular line of frozen confections. Ben and Woody created a new cartoon character, Popsicle Pete, who for decades appeared in the company's ads and on their packages.

Popsicle Pete attracted the attention of Joseph Shorin, president of the Topps Chewing Gum Company in Brooklyn. Shorin was impressed with Gelman's work and ultimately offered Woody a chance to join the chewing gum/candy novelty company fulltime. Gelman accepted, but only on the condition that Ben Solomon was offered full employment too. Woody headed to Brooklyn to run the product development department for Topps, and Ben Solomon became the firm's art director.

An early assignment at Topps involved developing a kids-friendly comic strip, which would be wrapped around the Bazooka bubble gum product. The character was named Bazooka Joe, after Joe Jr., Shorin's oldest son. Woody rough-sketched his vision of an all-American-looking young teen and a group of buddies who would make up his gang. A suggestion was made in a meeting that Joe needed something to make him immediately identifiable, and suddenly Bazooka Joe had an eye patch. It was a spoof of a then-current ad campaign in which a male model appeared with an eye patch, above a headline proclaiming him "The man in the Hathaway shirt."

To illustrate this series of comic strips, Woody chose a veteran cartoonist-illustrator named Wesley Morse. Gelman was familiar with Morse's work from collecting decade-long runs of old magazines and newspapers such as *Film Fun* and the daily *New York Graphic*. He felt Wesley's style would reproduce well on the inexpensive wax paper on which the four-color comic strip would be printed.

Two or three times a year, a series of roughly fifty new Bazooka Joe comics were packaged in the product, along with a fortune and an ad for a toy premium that could be redeemed from Topps by mailing in a collection of old *Bazooka* comics and some small change to cover the cost of shipping and handling. As a matter of economics, it was decided that after seven years, older *Bazooka* comics could be recycled, as a new generation had grown up to become the new bubble-gum consumers.

Wesley Morse would show up at Thirty-Sixth Street in Brooklyn to deliver his latest drawings and to pick up a check for his artwork. Woody arranged

for weekly advance payments in the amount of $75 to be paid to Morse. When Wesley became too sick to work, Woody would write the artist a personal check to help keep him afloat. It was just one example of Gelman's kind heart and of his loyalty to the people with whom he worked.

I joined Topps in 1959 as an eighteen-year-old assistant to Woody. The product development department did not have a secretary, and Woody needed someone to answer mail, file correspondence, and help with the daily chores that were necessary to keep the department functioning. I still remember my first day on the job back in 1959. Woody stood by my desk with a stack of *Boys' Life* magazines. He explained that the last page of every issue was made up of old, stale jokes submitted by readers. I was to read through them and see if any could be edited and worked up as a *Bazooka Joe* comic gag. Much of the humor of early *Bazooka Joe* comics came from that old joke page in *Boys' Life*. I would type up the selected jokes and get them ready for Wesley Morse's next visit to the Topps offices. It wasn't until years later that we finally assigned freelance writers to create original jokes and situations for Joe and his gang.

Several weeks ago, while watching the nightly news, I learned that the marketing people at Topps were discontinuing the old *Bazooka Joe*

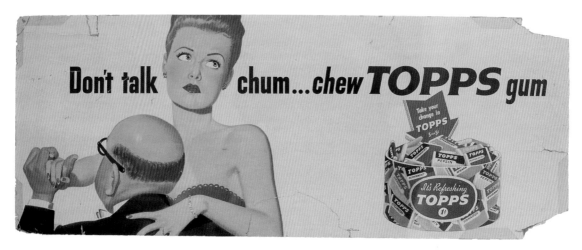

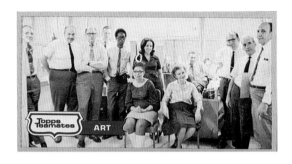

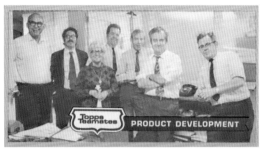

comic strip, which had survived for sixty years. Naturally I was was saddened to hear this. Yet, I'm willing to bet anyone that we haven't seen or heard the last of Bazooka Joe and His Gang. Just as "Ah-nold" used to say in all of those Terminator movies—"I'll be back."

Woody Gelman passed away in 1978, having been one of the Topps Company's most creative executives. In more than two decades there, Woody was responsible for having a hand in such successful products as the first Topps baseball cards, as well as cards and stickers on Elvis Presley, Wacky Packages, Mars Attacks, Davy Crockett, Hopalong Cassidy, the Civil War, the Beatles, Funny Valentines, football, hockey, basketball, and hundreds of other Topps properties. His creativity, insight, spirit, and great human kindness have always been missed.

LEN BROWN, former creative director at Topps, where he worked for more than forty years, is a writer and editor best known as the co-creator of Mars Attacks and of the comic book series *T.H.U.N.D.E.R. Agents*. He lives in Texas.

OPPOSITE: Pre-Bazooka Joe World War II–era subway poster advertising one-cent Topps chewing gum.

ABOVE: *Topps Teamates* trading cards, 1970. Produced for employees and never distributed to the public, there were eighteen cards in all. Featured here are cards no. 4, "Art" (standing, left to right: Jim McConnell, Hal Eisman, Ted Moskowitz, Paul Wuorinem, Rudy Martin, Louisa Fusco, Sid Hassin, Joe Goteri, Ben Solomon; seated, left to right: Liz Reed, Vera Sapsin, and Ray Hammond); and no. 15, "Product Development" (left to right: Dave Friedman, Len Brown, Fay Fleischer, Marvin Katz, Richard Varesi, Woody Gelman, and Larry Riley).

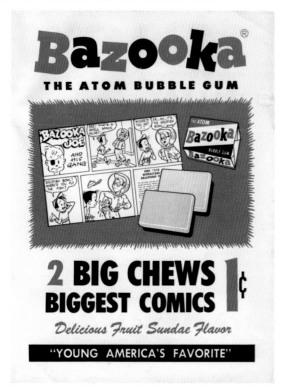

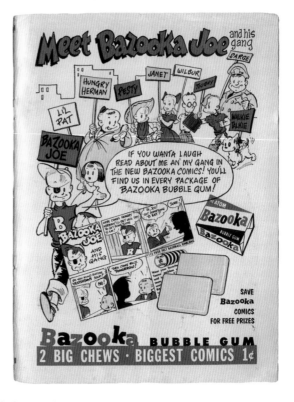

LEFT: Ad featuring mock-up Bazooka Joe gum comic, March 1954. The final version of this comic strip appears on page 82.
RIGHT: Ad introducing Bazooka Joe and His Gang, April 1954.

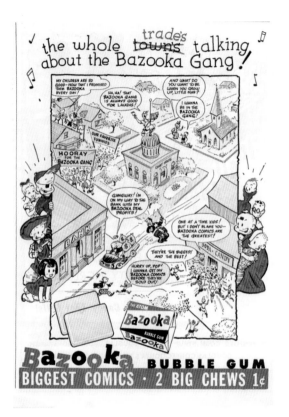

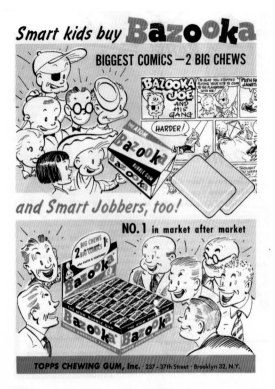

LEFT: Confectionery trade ad, July 27, 1954.
RIGHT: Confectionery trade ad, September 21, 1954.

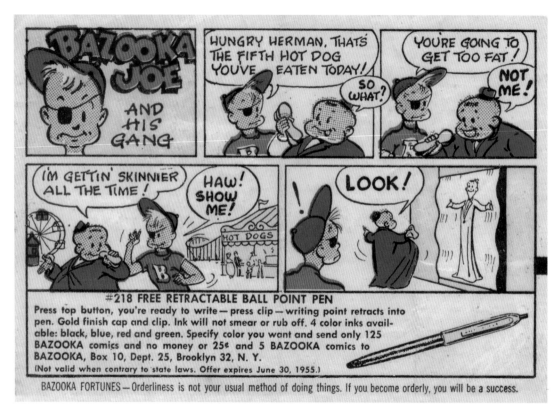

Reproduced for the first time in almost sixty years, here is the complete first series of forty-eight *Bazooka Joe* comics from 1954. Included in this series are the eight character comics that appear as the opening pages of this book.

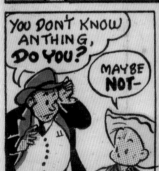

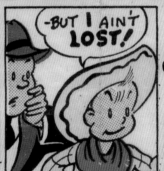

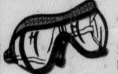

#132 FREE AIR COMBAT GOGGLES

Swell for fast bike riding... to protect your eyes from wind and dust. Send 75 BAZOOKA comics and no money or only 15¢ and 5 BAZOOKA comics to BAZOOKA, Dept. 16, Box 5, Brooklyn 32, N. Y.

BAZOOKA FORTUNES — Do not ever be content to follow others. You are born to lead, and you must do so without fear of what may happen.

(Not valid when contrary to state laws. Offer expires June 30, 1955.)

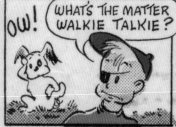

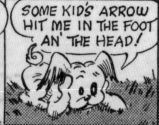

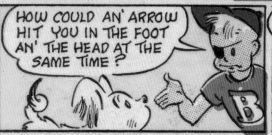

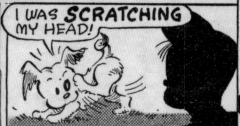

#217 FREE WESTERN BIKE SADDLE

Fits any bike. Just the thing for junior grade cowhands. What fun you will have when you saddle up with this genuine copy of a western bronc saddle — authentic in every detail. Send 625 BAZOOKA comics and no money or $1.25 and 10 BAZOOKA comics to BAZOOKA, Box 20, Dept. 24, Brooklyn 32, N. Y.

(Not valid when contrary to state laws. Offer expires June 30, 1955.)

BAZOOKA FORTUNES — Your fondness for reading will be most helpful to you in your future career. Read as much as you can.

SAVE **Bazooka** COMICS FOR FREE PRIZES

BAZOOKA FORTUNES — You will spend a long period of your life completely alone. This might possibly be spent on an island.

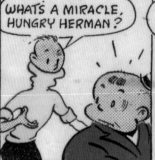

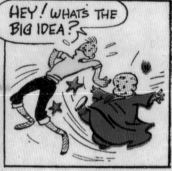

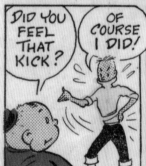

#219 FREE BAZOOKA CAMP KNIFE

Free! A genuine camp knife with 4 blades — cutting blade, can-opener, leather punch-awl and screwdriver cap-lifter. Full size 3⅝". Just the thing for hiking and camping. Get this swell knife free for only 375 BAZOOKA comics and no money or send 75¢ and 10 BAZOOKA comics to BAZOOKA, Dept. 26, Box 20, Brooklyn 32, N. Y.

(Not valid when contrary to state laws. Offer expires June 30, 1955.)

BAZOOKA FORTUNES — Be careful of friends who are false. You are very easily led into the wrong actions because of bad advice from others.

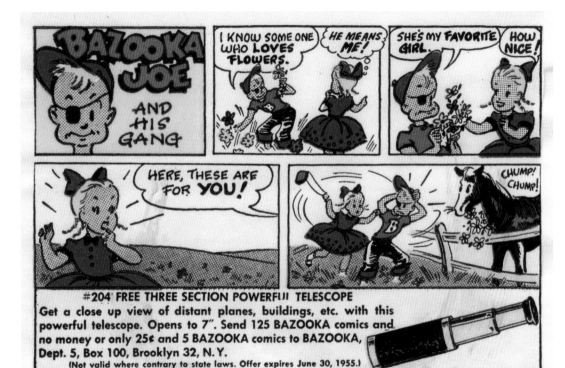

BAZOOKA FORTUNES — You will have a gift for making money all through your life. Use it well, and you will always be happy.

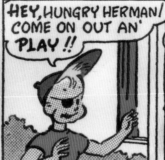

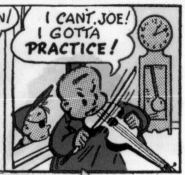

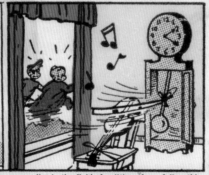

=207 **FREE 2-BLADED KNIFE**
Swell for whittling and carving, etc.
Carbon steel blades. 12″ chain. Send
125 BAZOOKA comics and no
money or only 25¢ and 5 **BAZOOKA**
comics to BAZOOKA, Dept. 3, Box
20, Brooklyn 32, N.Y.
(Not valid where contrary to state laws.
Offer expires June 30, 1955.)

BAZOOKA FORTUNES — Your success lies in the field of politics. If you follow this,
you may rise to very great heights as a statesman.

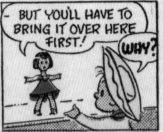

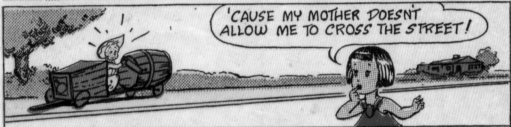

BOYS! GIRLS! #206 FREE, 22 KT. GOLD PLATED RING WITH YOUR INITIAL

Get this genuine 22 carat gold plated ring with your own initial. Fits any finger.
Print one initial and send 125 BAZOOKA comics and no money or only 25¢ and
5 BAZOOKA comics to BAZOOKA, Dept. 1, Box 10, Brooklyn 32, N.Y.
(Not valid where contrary to state laws. Offer expires June 30, 1955.)

BAZOOKA FORTUNES — The power to sway millions by your speeches will come to you in your later life. Don't misuse this gift.

SAVE **Bazooka** COMICS FOR FREE PRIZES

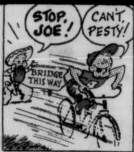

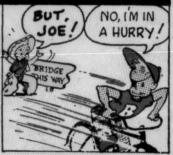

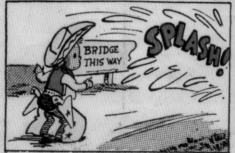

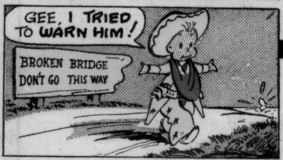

BAZOOKA FORTUNES — Some day your name will be in the headlines in all the newspapers. Don't let this turn your head.

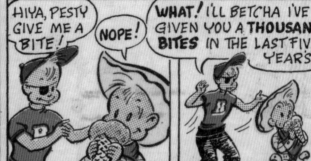

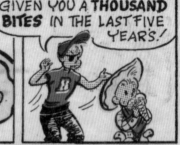

#115. FREE FELT BASEBALL EMBLEMS

BAZOOKA FORTUNES — Because of your fine mental power, your future lies in the study of law. You will become famous as an attorney.

Wear your favorite Major League Teams' emblem with team name and insignia. 5" diameter. Name team and send 75 BAZOOKA comics and no money or only 15¢ and 5 BAZOOKA comics for EACH emblem to BAZOOKA, Dept. 14, Box 20, Brooklyn 32, N. Y.

(Not valid where contrary to state laws. Offer expires June 30, 1955.)

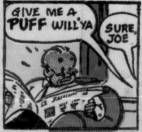
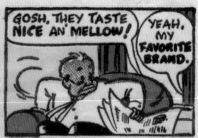
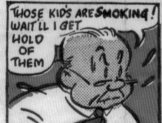
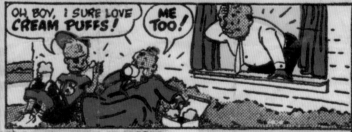

#204 FREE THREE SECTION POWERFUL TELESCOPE
Get a close up view of distant planes, buildings, etc. with this powerful telescope. Opens to 7". Send 125 BAZOOKA comics and no money or only 25¢ and 5 BAZOOKA comics to BAZOOKA, Dept. 5, Box 100, Brooklyn 32, N.Y.
(Not valid where contrary to state laws. Offer expires June 30, 1955.)

BAZOOKA FORTUNES — You will be able to look forward to a long life of happiness, provided you learn to curb your temper.

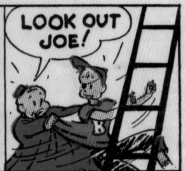

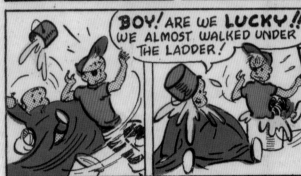

BAZOOKA FORTUNES — You will be very charitable, and will never lack for money or good friends. You will be happy through your life.

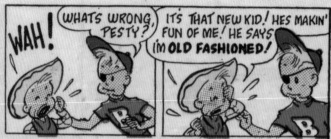

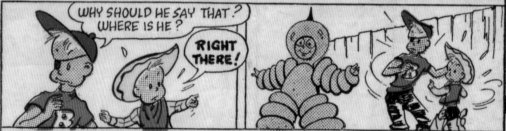

BOYS! GIRLS! #206 FREE 22 KT. GOLD PLATED RING WITH YOUR INITIAL.

Get this genuine 22 carat gold plated ring with your own initial. Fits any finger.
Print one initial and send 125 BAZOOKA comics and no money or only 25¢ and
5 BAZOOKA comics to BAZOOKA, Dept. 1, Box 10, Brooklyn 32, N.Y.
(Not valid where contrary to state laws. Offer expires June 30, 1955.)

BAZOOKA FORTUNES — In the future, you will do a great deal of traveling, and most of it will be at someone else's expense.

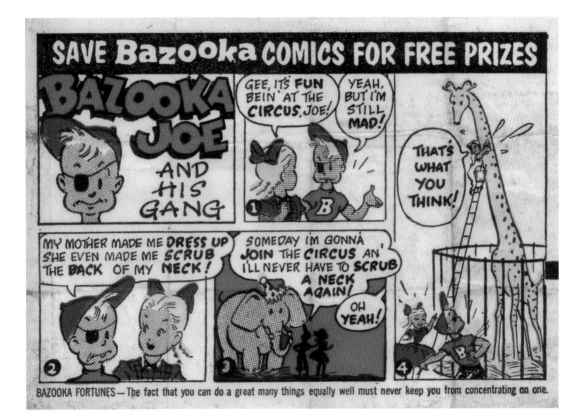

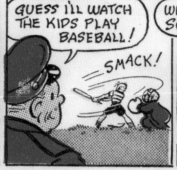

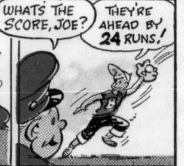

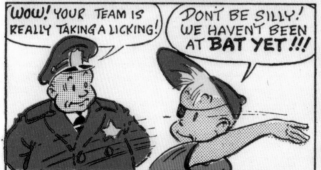

#132 FREE
AIR COMBAT
GOGGLES

Swell for fast bike riding... to protect your eyes from wind and dust. Send 75 BAZOOKA comics and no money or only 15¢ and 5 BAZOOKA comics to BAZOOKA, Dept. 16, Box 5, Brooklyn 32, N. Y.

BAZOOKA FORTUNES — You will become known for your excellent taste in clothes. All the people around you will envy you your wardrobe.

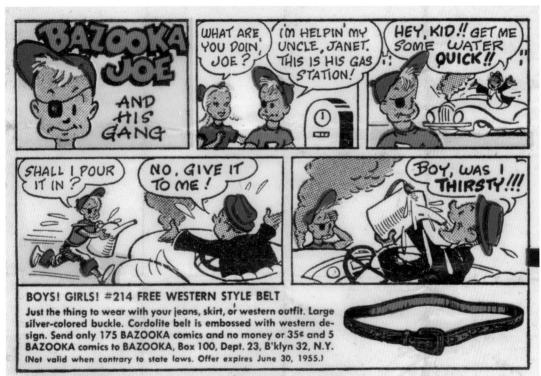

BOYS! GIRLS! #214 FREE WESTERN STYLE BELT

Just the thing to wear with your jeans, skirt, or western outfit. Large silver-colored buckle. Cordolite belt is embossed with western design. Send only 175 BAZOOKA comics and no money or 35¢ and 5 BAZOOKA comics to BAZOOKA, Box 100, Dept. 23, B'klyn 32, N.Y. (Not valid when contrary to state laws. Offer expires June 30, 1955.)

BAZOOKA FORTUNES — You will always be able to adapt yourself to any situation that may arise, and make the best of it.

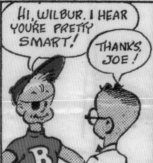

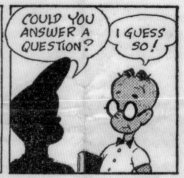

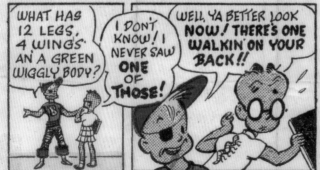

BAZOOKA FORTUNES — The medical profession is the one you will follow, either as a nurse or a doctor. Prepare for it and work hard.

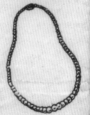

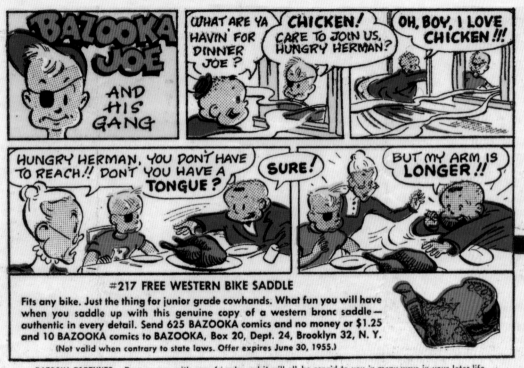

#217 FREE WESTERN BIKE SADDLE

Fits any bike. Just the thing for junior grade cowhands. What fun you will have when you saddle up with this genuine copy of a western bronc saddle — authentic in every detail. Send 625 BAZOOKA comics and no money or $1.25 and 10 BAZOOKA comics to BAZOOKA, Box 20, Dept. 24, Brooklyn 32, N. Y.

(Not valid when contrary to state laws. Offer expires June 30, 1955.)

BAZOOKA FORTUNES — Be generous with your friends, and it will all be repaid to you in many ways in your later life.

SAVE Bazooka COMICS FOR FREE PRIZES

BAZOOKA FORTUNES — You are fortunate in having a very artistic nature, and some day you will be famous because of this gift

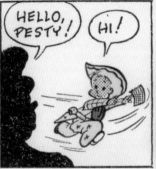

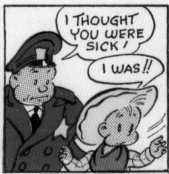

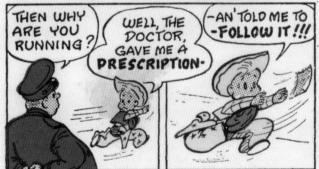

BAZOOKA FORTUNES — You are going to be extremely successful in anything that is connected with either music, painting, or the art of dancing.

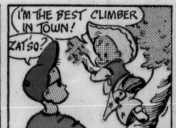
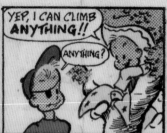
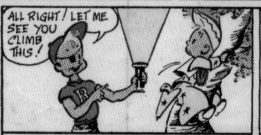
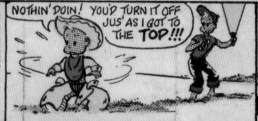

BAZOOKA FORTUNES — You know how to take command of a situation, and that talent will be one to put you in an executive job.

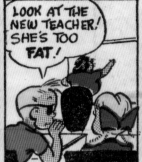

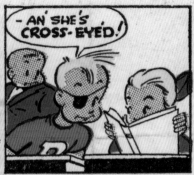

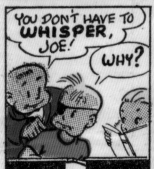

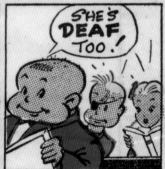

BAZOOKA FORTUNES — You are the type who will always look for new adventures. You may find your fame as an explorer of new territories.

#219 FREE BAZOOKA CAMP KNIFE

Free! A genuine camp knife with 4 blades — cutting blade, can-opener, leather punch-awl and screwdriver cap-lifter. Full size 3⅛" Just the thing for hiking and camping. Get this swell knife free for only 375 BAZOOKA comics and no money or send 75¢ and 10 BAZOOKA comics to BAZOOKA, Dept. 26, Box 20, Brooklyn 32, N. Y.

(Not valid when contrary to state laws. Offer expires June 30, 1955.)

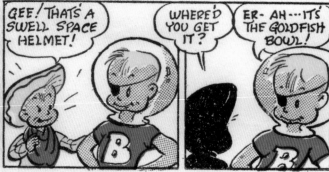

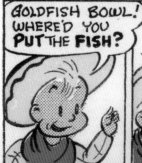

#162 FREE! JERRY MAHONEY

Wear Jerry on your key chain. His eyes roll! His lips move! Be a ventriloquist. Send 125 BAZOOKA comics and no money or only 25¢ and 5 BAZOOKA comics to BAZOOKA, Dept. 8, Box 5, Brooklyn 32, N. Y

BAZOOKA FORTUNES — Your success will come to you only through hard work with your hands. You must develop this ability.

(Not valid when contrary to state laws. Offer expires June 30, 1955.)

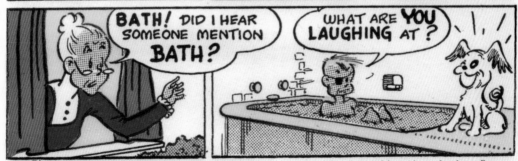

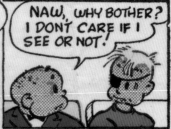
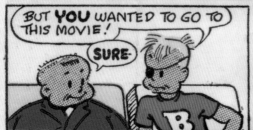
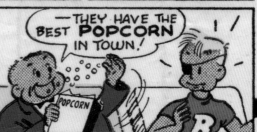

#203 FREE TEN YEN CHINESE MYSTERY PUZZLE

450 different combinations with plastic cut-outs. 3 different colors. Works like a jig-saw puzzle. Amaze your friends! Send 125 BAZOOKA comics and no money or only 25¢ and 5 BAZOOKA comics to BAZOOKA, Dept. 9, Box 100, Brooklyn 32, N. Y.

(Not valid when contrary to state laws Offer expires June 30, 1955.)

BAZOOKA FORTUNES — Do not ever let pride stand in your way You will get what you want if you will be much more humble.

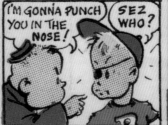

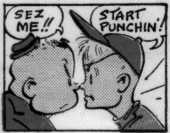

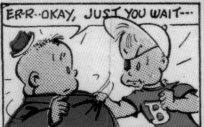

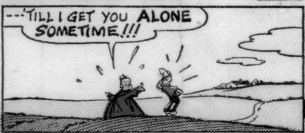

#211 FREE WALLET

Lizagator grain with acetate card holder. Full-size, just like Dad's. Holds money, cards, pictures, etc. Has a secret compartment. Electronically sealed Send 125 BAZOOKA comics and no money or only 25¢ and 5 BAZOOKA comics to BAZOOKA, Box 20, Dept. 20, Brooklyn 32, N. Y.

(Not valid when contrary to state laws. Offer expires June 30, 1955.)

BAZOOKA FORTUNES — You will have a large family and a great many grandchildren. They will all be very fond of you.

BAZOOKA JOE
AND HIS GANG

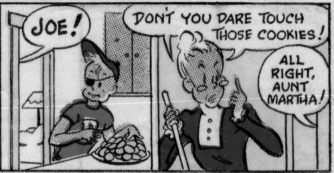

JOE!

DON'T YOU DARE TOUCH THOSE COOKIES!

ALL RIGHT, AUNT MARTHA!

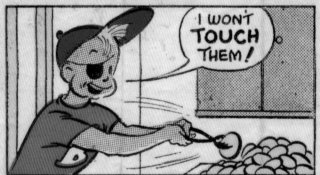

I WON'T TOUCH THEM!

BAZOOKA FORTUNES — The power to heal others is within you. Train yourself for a fine career in the medical profession.

CHICAGO CUBS N.Y. GIANTS
#121

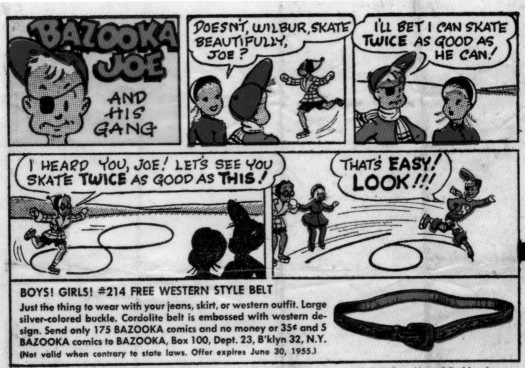

BAZOOKA FORTUNES—You will be blessed with good health all your life, and you will live to an old age full of happiness.

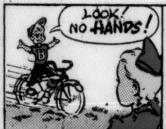

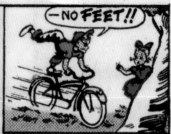

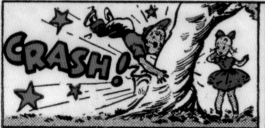

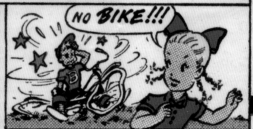

#211 FREE WALLET

Lizagator grain with acetate card holder. Full-size, just like Dad's. Holds money, cards, pictures, etc. Has a secret compartment. Electronically sealed. Send 125 BAZOOKA comics and no money or only 25¢ and 5 BAZOOKA comics to BAZOOKA, Box 20, Dept. 20, Brooklyn 32, N. Y.
(Not valid when contrary to state laws. Offer expires June 30, 1955.)

BAZOOKA FORTUNES — Once you are married, you can look forward to doing a great deal of traveling to all parts of the world.

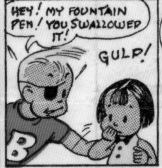

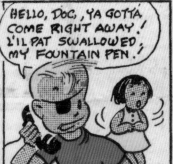

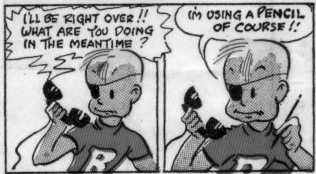

BAZOOKA FORTUNES — If you are not careful you are likely to become a hermit. You must get out more and mingle with people. Find friends.

#108 FREE PERFUMED NECKLACE Fine filigree pendant. Renew with your own perfume. Gold plated chain with clasp. Fellows, here's a swell gift for your favorite girl friend. Send 125 BAZOOKA comics and no money or 25¢ and 5 BAZOOKA comics to BAZOOKA, Dept. 4, Box 20, Brooklyn 32, N. Y. (Not valid when contrary to state laws. Offer expires June 30, 1955.)

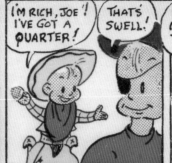

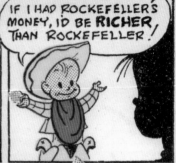

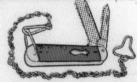

#207 FREE! 2-BLADED KNIFE

Swell for whittling and carving, etc. Carbon steel blades. 12" chain. Send 125 BAZOOKA comics and no money or only 25¢ and 5 BAZOOKA comics to BAZOOKA, Dept. 3, Box 20, Brooklyn 32, N.Y.

BAZOOKA FORTUNES — The person you marry will be your exact opposite in likes and dislikes, but you will live through many years of married bliss.

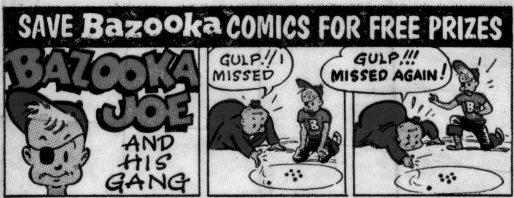

#218 FREE RETRACTABLE BALL POINT PEN

Press top button, you're ready to write — press clip — writing point retracts into pen. Gold finish cap and clip. Ink will not smear or rub off. 4 color inks available: black, blue, red and green. Specify color you want and send only 125 BAZOOKA comics and no money or 25¢ and 5 BAZOOKA comics for each pen to BAZOOKA, Box 10, Dept. 25, Brooklyn 32, N.Y.

(Not valid when contrary to state laws. Offer expires June 30, 1955.)

BAZOOKA FORTUNES — Your fine ability to get along with people means a possible future for you in the diplomatic service.

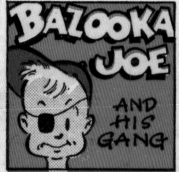

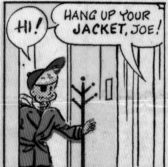

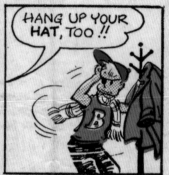

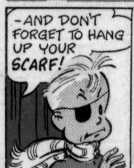

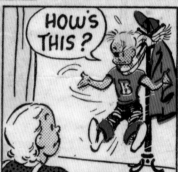

#200 FREE GOLD AND SILVER PLATED CHARMS
5 to a set. Wear these rich looking charms on a bracelet or beanie hat. Send 75 BAZOOKA comics and no money or only 15¢ and 5 BAZOOKA comics to BAZOOKA, Dept. 10, Box 5, Brooklyn 32, N. Y.
(Not valid where contrary to state laws. Offer expires June 30, 1955.)

BAZOOKA FORTUNES — You have within you the ability to be a great artist, but your first job will be to learn to relax and be happy.

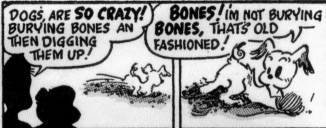
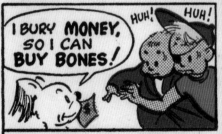
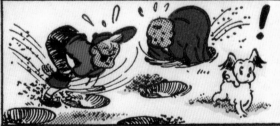

BOYS! GIRLS! #206 FREE 22 KT. GOLD PLATED RING WITH YOUR INITIAL

Get this genuine 22 carat gold plated ring with your own initial. Fits any finger.
Print one initial and send 125 BAZOOKA comics and no money or only 25¢ and
5 BAZOOKA comics to BAZOOKA, Dept. 1, Box 10, Brooklyn 32, N.Y.
(Not valid where contrary to state laws. Offer expires June 30, 1955.)

BAZOOKA FORTUNES — Do not let shyness stand in the way of your chosen career. Once you overcome it, you will succeed.

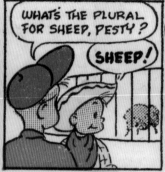
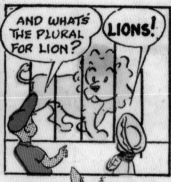
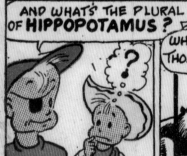
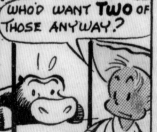

BAZOOKA FORTUNES — You will become known for your excellent taste in clothes.

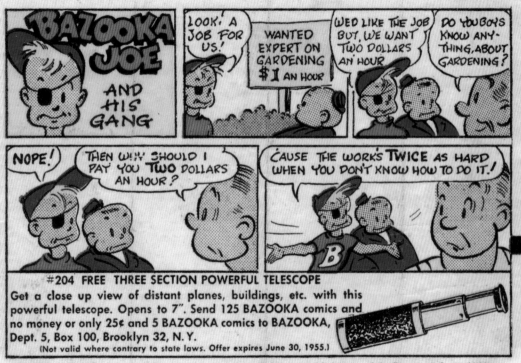

BAZOOKA FORTUNES — You are destined to have great riches and honor, mainly because of the fine power of your thinking.

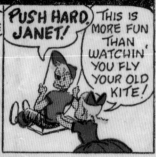

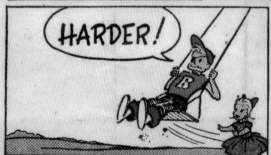

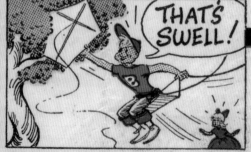

BAZOOKA FORTUNES — You will have great physical power, and you will become famous because of your feats of great strength.

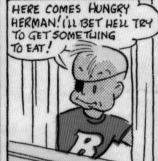

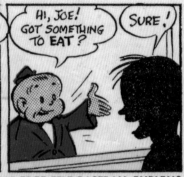

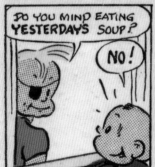

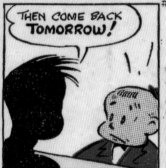

BAZOOKA FORTUNES — Don't let a pretty face turn your head. You will find this leading to much more trouble than you would ever expect.

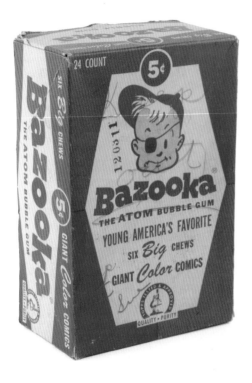

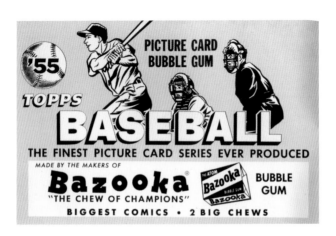

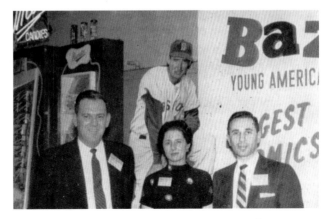

OPPOSITE LEFT: Five-cent store display box, 1950s.

OPPOSITE RIGHT: Two varieties of five-cent foil comics issued in 1954. All subsequent gum comics would be printed on wax paper, except for a brief set on foil released in the early 1970s.

TOP: Major League Baseball yearbook ad promoting Topps baseball cards and Bazooka gum, 1955.

BOTTOM: The Topps booth at the 1957 NATD Candy Convention. Pictured, left to right, are Herman Fine (regional sales manager, southern markets), Joyce Shorin (sales administration manager and daughter of Ira Shorin, one of the four founding brothers of Topps), and Charles Zubrin (merchandising manager) in front of a large Ted Williams Bazooka display.

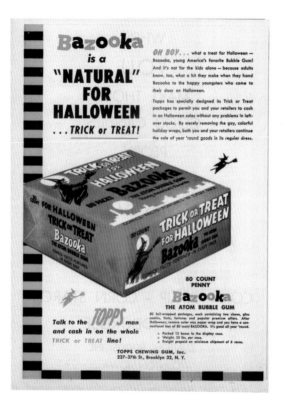

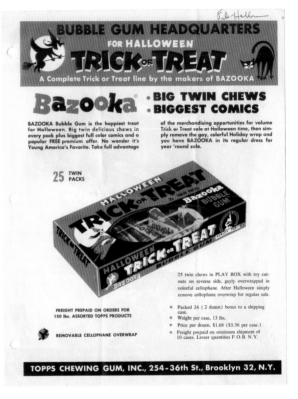

LEFT: Halloween confectionery trade ad, July 15, 1952.
RIGHT: Topps Halloween sell sheet, 1957.

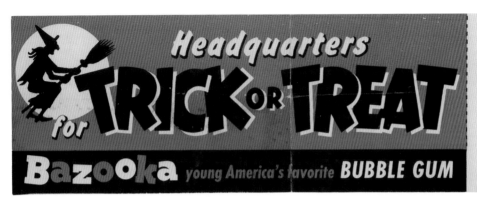

Headquarters for *TRICK OR TREAT*

Bazooka *young America's* favorite **BUBBLE GUM**

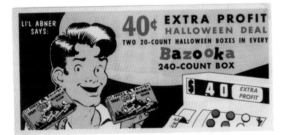

LI'L ABNER SAYS:

40¢ EXTRA PROFIT
HALLOWEEN DEAL
TWO 20-COUNT HALLOWEEN BOXES IN EVERY
Bazooka
240-COUNT BOX

$.40 EXTRA PROFIT

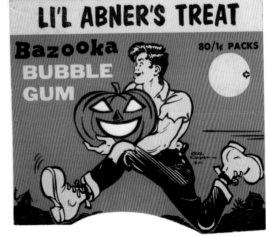

LI'L ABNER'S TREAT

Bazooka BUBBLE GUM

80/1¢ PACKS

TOP: Halloween window poster for retailer displays, c.1957.
BOTTOM LEFT: Retailer display card found in boxes of 240-count one-cent Bazooka. c.1957. Topps briefly used the work of Al Capp by licensing his Li'l Abner comic strip character for promotion.
BOTTOM RIGHT: Display header for eighty-count Halloween bags of Bazooka.

Bazooka & BLONY
BUBBLE GUM
BROOKLYN 32, NEW YORK

Dear Friend:

We're happy to send you the Emblem of your favorite Team as a gift from Bazooka Joe and Archie.

It's swell to count you among the many Baseball Fans and Major League Ball Players who chew BAZOOKA and BLONY, young America's favorite Bubble Gums.

I guess I know there are lots of other interesting and exciting prizes you can get free just by saving the big, four color comics in every pack of BAZOOKA and BLONY. I pictured a few of the prizes on the back of this letter but you will see them all while you're saving the comics for the prizes you want.

Hope to hear from you again soon.

Bazooka Joe
+ Archie

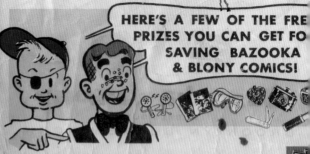

HERE'S A FEW OF THE FRE PRIZES YOU CAN GET FO SAVING BAZOOKA & BLONY COMICS!

#400—CARDINAL CAMERA Takes sharp, clear photos. 16 pictures on each roll of standard #127 Film. Comes with instruction book and guarantee. It's yours for 250 BAZOOKA or BLONY Comics or 50¢ and 10 Comics.

#132—AIR COMBAT GOGGLES Swell for fast bike riding. Keeps wind and dust of your eyes. Just send 75 BAZOOKA or BLONY Comics or 15¢ and 5 Comic

#206—GOLD PLATED INITIAL RING Genuine 22 Kt. Gold Plated Ring with your own initial. Adjustable to fit any finger. Print only one initial you want and send 125 BAZOOKA or BLONY Comics or 25¢ and 5 Comics.

#231—TWO NOVELS Pick any 2 of these mystery and adventure books: D Crockett; Danger Mountain; Wild Bill Hickok; Egyptian Mystery; The Sunken S Curious Creatures; Mystery Marble Face. For both books send 100 BAZOOKA BLONY Comics or 20¢ and 5 Comics.

#207 — TWO-BLADED KNIFE Great for whittling. Swell for carving. Carbon steel blades and a 12″ chain. Yours for 125 BAZOOKA or BLONY Comics or 25¢ and 5 Comics.

 #204 — HIGHPOWER TELESCOPE Spot planes, see ball games close-up with 3-section telescope. Opens to a full 7 inches! Yours for 125 BAZOOKA or BLO Comics or 25¢ and 5 Comics.

 #108 — PERFUMED NECKLACE Gold plated filigree heart on graceful chain. Refill with your own perfume. Makes a great gift for Mom or your special girl. Just send 125 BAZOOKA or BLONY Comics or 25¢ and 5 Comics.

 #401 — TWO-WAY SPACE PHONES Amazing aluminum space phones. Great sending secret messages to pals in other houses or rooms. Yours for 125 BAZOO or BLONY Comics or 25¢ and 5 Comics.

MAILING INSTRUCTIONS

Select the prize or prizes you want. Write the order number on a piece of paper and pr your name and address clearly. Put it with the required number of BAZOOKA or BLON Comics in an envelope. Mail to:

BAZOOKA JOE & ARCHIE
BROOKLYN 32, NEW YORK

Your prize will be sent to you promptly.

Comics not transferable. Valid only where legal in U.S.A. and obtained through normal BAZOOKA BLONY purchases by redeemer. Premium values changeable without notice.

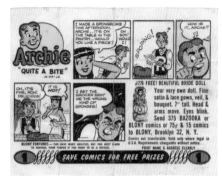

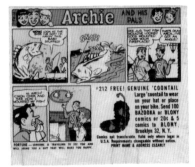

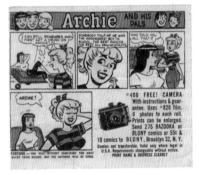

In 1957, Topps released an alternate brand of bubble gum called Blony, featuring licensed Archie comic strips in the same format as Bazooka Joe. Blony had been a popular brand for Gum, Inc. (later Bowman Gum), beginning in the early 1930s, which was eventually sold to Topps in April 1956. In this 1957 premium catalog, Bazooka Joe and Archie join forces.

OPPOSITE: Topps letter from Bazooka Joe and Archie, 1957–58; premium catalog, 1957.
ABOVE: Archie comics released with Blony, 1957–58.

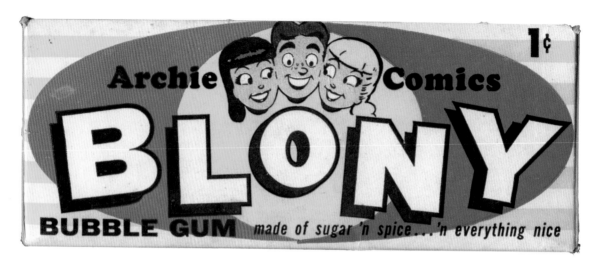

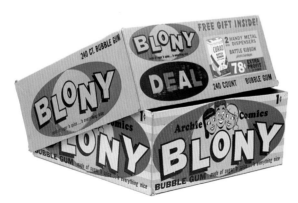

Blony box and side panels, wrappers, and unopened pieces of gum, 1957–58. Veronica Lodge, Archie Andrews, and Betty Cooper are featured on the box on the left; Hungry Herman of the Bazooka Joe gang is featured on the box on the right.

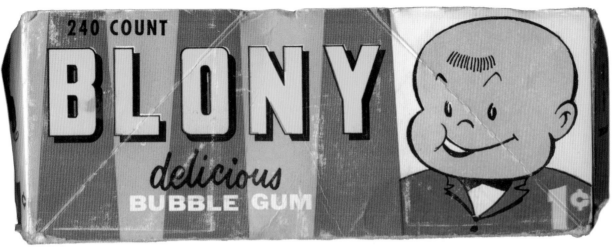

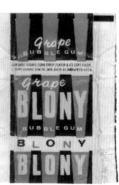

BUBBLING OVER

BY BHOB STEWART

Since Topps has sold a billion and a half pieces of Bazooka bubble gum annually and the *Bazooka Joe* strip is read internationally, surely Bazooka Joe must be one of the most familiar comics characters of the twentieth century. The strip has even had an impact on style and fashion, teaching kids around the world how to wear their baseball caps sideways and pull their turtleneck sweaters up to their noses.

The main offices of Topps were located in Brooklyn but moved to Manhattan in 1994. Until 1996, the gum was made at a plant in Duryea, Pennsylvania, where various conveyor belts, coated gum polishers, and suspended tubes filled a football-field-size room. I watched that machinery in motion as Bazooka gum was manufactured and then joined with the *Bazooka Joe* comic strips. At the starting point, loaves of gum were inserted into a Rube Goldberg–like

hopper, where they were then mashed into a rope shape that traveled out of the hopper on a conveyor belt. Products of various sizes were then sliced out of the sugary rope as it moved along.

At the far end, a machine spit out small pieces of gum at an incredible rate. *Phtt!* There went the gum. *Whht!* A strip of comics was sliced off. *Fffftt!* The wrapper was whipped on. And it all happened faster than you could *open* the package—gum, *Bazooka Joe* comics, wrapper—all spinning and whizzing at a blinding speed.

One could not stand in front of this grandiose gum gadget without visualizing ten million mouths desperately gnawing and chewing in a futile effort to keep pace with the Topps machinery.

If you ever wondered why the edges were chopped off some *Bazooka Joe* strips, the aforementioned description should give you the answer. The machine clipped off those strips—*whht, whht, whht*—so fast that a dozen could flip out even as the operator reached to adjust the positioning of the *Bazooka Joe* roll.

Bazooka Joe is seen internationally because the comics are printed in many languages, including Spanish, French, German, and Hebrew. According to Robert Hendrickson's *The Great American Chewing Gum Book* (Chilton, 1976), at that time *Bazooka Joe* was trademarked in thirty countries and Topps products were sold in fifty-five countries with licensed manufacturers in ten of those countries. In Nigeria, a black Bazooka Joe told jokes Nigerian-style. But the Japanese never got stuck on the gum, as noted by Paul Gravett in "The Mystery of Bazooka Joe" (*Escape* no. 1, 1983): "One country, however, where you won't find Joe is Japan, not even in

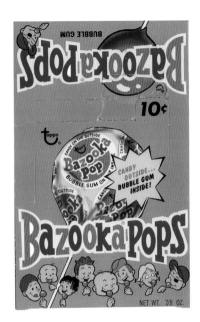

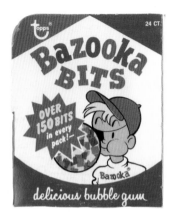

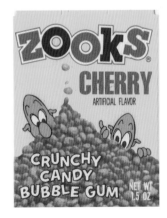

OPPOSITE: "Bazooka the Atom Bubble Gum" store window decal, 1947.

ABOVE: Bazooka Pops store display box, 1970s.

TOP RIGHT: Bazooka Bits store display box, 1970s.

BOTTOM RIGHT: Cherry Zooks candy box, Topps's answer to Nerds Candy, 1985.

Tokyo, due to their restrictions on the sale of gums that stick . . . Bubble gum had the one social failing of being sticky."

Bazooka Joe has a product identification that spans the globe and leaps generations. But for the most part, Bazooka Joe and his pals remain confined to their little world of simple gags, tiny rectangles, and even tinier talking heads. True, there was the *Bazooka Super Fun Pad*, a 1983 activity book published by Playmore Waldman. The *Super Fun Pad* presents the characters at a much larger size in follow-the-dot pages, color-by-number pictures, games, magic tricks, and mazes.

Another exception is the GAF Corporation's View-Master reel packet, "Bazooka Joe and His Gang." Topps licensed the character to GAF in 1973, and Bazooka Joe joined the View-Master series of "Cartoon Favorites," a grouping of about twenty-five comic strip animation properties that included Bugs Bunny, Dennis the Menace, Superman, the *Peanuts* gang, Mighty Mouse, and Bullwinkle. The packet contained three seven-scene reels, so the Topps characters could "Come to Life" (as GAF put it) in twenty-one full-color, three-dimensional "stereo pictures."

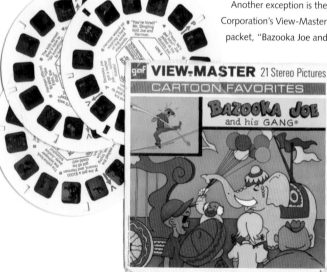

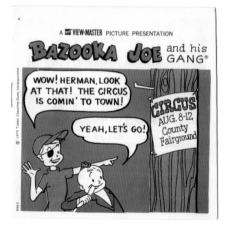

Accompanying the stereoscope reels is a detailed storyline, typeset in a sixteen-page booklet ("A GAF View-Master Picture Presentation") with eight two-color illustrations and a story synopsis.

The standard *Bazooka Joe* format has no continuity, but View-Master put the characters into a full-length story, rather than "gag-a-day" situations. Yet by the time the reader of the View-Master booklet reaches page sixteen, it's evident that one still knows *nothing*

about Bazooka Joe. Well, okay, he lives in Prairie City, but where is that?

I worked on *Bazooka Joe* once, but even that close connection provides no great insights into Joe's background and life in Prairie City (a name probably provided by GAF, not Topps). The assignment was twofold: 1) write new fortunes to go beneath the strip, and 2) edit the *Bazooka Joe* dialogue for the 1972 bilingual versions: "Learn French with Bazooka Joe" and "Learn Spanish

with Bazooka Joe." Every balloon remained the same size, but the original English dialogue within that balloon had to be edited down considerably to make space for the same line in Spanish or French.

Editing the dialogue posed no problem. Gag lines usually worked better when shortened anyway. The fortunes were another matter. In 1973, to write "Kung Fu Sayings" for the back of Topps's *Kung Fu* cards, I simply adapted lines

View-Master from GAF, 1973.

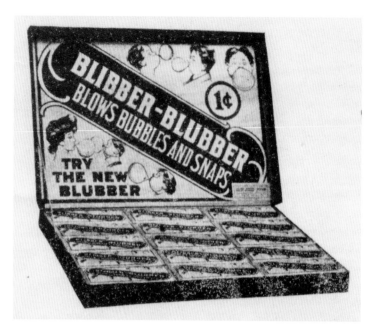

Blibber Blubber display box from Fleer Chewing Gum product catalog, 1908.

blank sheet of paper. It was a bafflement, until I decided to satirize the straight-ahead *Bazooka* fortunes.

Over a decade later, comedian Rich Hall appeared on *Late Night with David Letterman,* pulled out a *Bazooka Joe* strip, kidded "the guys who write for this," and got a laugh when he read a *Bazooka* fortune ("What you think will happen, will"), commenting, "That's not really going out on a limb or anything, I guess." Another big laugh. I laughed, too. Then it slowly dawned on me: I was the guy who had written that particular fortune thirteen years prior.

Tracking the origins of Bazooka Joe, we can open the National Geographic's *Atlas of the World* and find two states with a Prairie City—Oregon and South Dakota. Pretty remote, and doesn't reveal much. So, for the nonce, let's take another tack: Before Bazooka Joe, there was gum. The Aztecs chewed chicle, the dried sap of the sapodilla tree. General Santa Anna (1794–1876) came to New York and struck a chicle deal with

from the verses in Lao Tzu's *Tao Te Ching* (since the creator of the *Kung Fu* TV series obviously went to this same source). For *Bazooka* fortunes I was stymied, unable to figure out exactly what a *Bazooka* fortune was supposed to be, and I sat staring at a

Thomas Adams (1818–1905), who then began some kitchen experiments to find a "new kind of rubber." Instead, after witnessing a little girl make a drugstore purchase of White Mountain paraffin wax gum, Adams and his sons packaged unsweetened chicle chewing gum balls in boxes (two hundred to a box), devised a brand name and slogan (Adams' New York Gum No. 1—Snapping and Stretching), illustrated the boxes with a picture of New York City Hall, and soon had twenty-five young women wrapping gum in a Jersey City loft. Their loft was next door to a Loft, namely candy store owner George William Loft, who later expanded into one of the USA's largest candy store chains, handling more than 350 different types of Loft's Candy.

In 1871, Adams patented the first gum-making machine and then added shredded licorice to create the ever-popular Adams' Black Jack. The first penny candy with pieces individually wrapped in paper was the Tootsie Roll, and when Leo Hirschfield launched this product in 1896 he named it after his daughter, Clara "Tootsie" Hirshfield. Frank Henry Fleer, in 1906, concocted Blibber-Blubber, the first bubble gum, but this "wet" gum was abandoned. Then, in 1928, Walter Diemer (according to Fleer mythology) devised the "dry" formula for Fleer's one-cent Dubble Bubble, an overnight success that outsold the Tootsie Roll. On the fiftieth anniversary of his invention, Diemer reflected, "The other Walt got all the fame in 1928. That's the year Disney introduced Mickey Mouse. But we have the same initials. I prefer to be unknown. Do you know why the gum is pink? It's the only color I had at the time."

The color of money was also pink. J. Warren Bowman, down to his last twenty-five dollars, borrowed three hundred dollars and began Gum, Inc., which later became Bowman Gum, Inc., after World War II. Bowman outdistanced twenty other companies to become Fleer's chief competitor. Promoting his products with picture cards, Bowman made a fortune, cashing in at the rate of a million dollars a month and indulging in some peculiar eccentricities. When he vacationed at his Miami home, he employed a professional organist to perform at an amplified electric organ aimed at the ocean—so he could hear live music while he fished.

As the money bubble expanded, Topps entered the arena. The origins of the company can be traced back to Morris Shorin, founder of the American Leaf Tobacco Company. Shorin had four sons—Phil, Abe, Ira, and Joe—and during the Depression they experimented with a one-cent fruit-flavored gum. Topps took off in 1938, and introduced Bazooka in September 1947. First came the five-cent tube of bubble gum marketed in a Tootsie Roll–like shape, with one-cent Bazooka in 1949.

Joe became the president of Topps in 1941 and was the driving force behind the business. (And while many Shorins played a role over the years in what was then a family business, it was Joe's son

Arthur who led the charge during the eighties and nineties—its greatest period of growth—and for decades was the president and CEO.)

Meanwhile in schoolyards, kids chewed, blew bubbles, and chewed some more. When World War II was over, the bubble gum boom began and thousands of Bazooka wrappers fluttered through the canyons of Wall Street to inundate returning war heroes. This was one of Topps president Joe Shorin's greatest promotional stunts: deliver Bazooka wrappers to Wall Street, toss them out of windows, take a photograph, and send the photo to all the wire services. One afternoon's work—with the result that Bazooka gum received free publicity in newspapers across the country. The bubble continued to expand to such a degree that the Bowman Company was taken over by Topps on April 1, 1956.

Characters were then created to push the products. This was nothing new. Smith Brothers Cough Drops began when carpenter/candy maker/restaurant owner James Smith acquired the recipe from a passing customer and mixed up his first batch in Poughkeepsie, New York, in 1847. James Smith & Sons Compound of Wild Cherry Cough Candy was first advertised in 1852. When James Smith died in 1866, his two sons, Andrew and William, continued the family business, calling it the Smith Brothers. To discourage imitators (Smythe Sisters, Schmitt Brothers, and other Smith Brothers), they put their own portraits and the words "Trade Mark" on the glass bowls of cough drops displayed atop drugstore counters. The word "Trade" was placed beneath William's picture, and "Mark" appeared next to Andrew, chance juxtapositions that led drugstore customers to think of the hirsute duo as Trade Smith and Mark Smith, the Smith Brothers. The image became even more familiar in 1872 when the brothers reproduced it on their package (America's first "factory-filled" candy package). In 1926, it became a "living trademark"

when *The Smith Brothers* premiered on NBC radio. This was a show of songs and patter, starring Billy Hillpot as Trade and Scrappy Lambert as Mark.

When the owners of the White Rock Mineral Springs Company, bottlers of Ozonate Lithia Water, attended the 1893 World's Fair in Chicago, they saw a painting titled *Psyche at Nature's Mirror* by the German artist Paul Thurmann, acquired the rights, and inscribed the words "White Rock" on her stone perch. Thus was born Psyche the White Rock Girl, and today she's still visible, painted on the sides of trucks that continually cruise past my front door in Massachusetts.

Angelo Siciliano changed his name to Charles Atlas in the 1930s, and Mac, the ninety-seven-pound weakling, appeared in comic strip ads to move muscles by mail order. Captain Marvel co-creator C. C. Beck also created Captain Tootsie ads for Tootsie Roll; the character was given his own Toby Press comic book in 1950. The Sunday funnies

carried color comics for Necco's Bolster bar (*The Bolsters*), Nestlé (*Nestlé's Nest* and *Neddy Nestl*é), and Chuckles (*Chuckles at the Office*). Dik Browne, writer and artist of the comic strip *Hägar the Horrible*, drew the late-1940s Sunday comics adventures of Roger Wilco for the Walter H. Johnson Candy Company's Power House bar (later taken over by Peter Paul Candy). Back then, a Power House wrapper and fifteen cents could deliver an "exciting scientific Roger Wilco Magni-Ray Ring" to your doorstep.

Chicago's Williamson Candy Co. produced the Amos 'n' Andy bar during the 1930s, and Howdy Doody hustled the Mars coconut bar in the early 1950s. The Popsicle, invented in 1922 by Frank Epperson, was adopted as an Eighth Air Force icon during World War II (possibly because of the Popsicle's resemblance to the two side-by-side bombs clutched in the talons of the eagle insignia familiar to Bombardment Group fliers and ground crews). Actually, what Epperson first invented was the Epsicle,

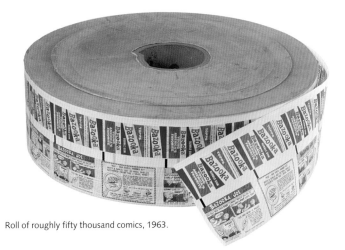

Roll of roughly fifty thousand comics, 1963.

created accidentally when he left a glass of lemonade with a stirring stick in it on an open windowsill during a record-low night in San Francisco. When he changed the "Ep" to "Pop" at the insistence of his children, the Popsicle was born. The five-cent twin Popsicle (two sticks frozen in the paper wrapper) was developed with the notion of sharing: A buyer could break it in half and give the other half to a friend. During the Depression some merchants raked in extra pennies by

selling each half for three cents. The twin Popsicle was eventually replaced by a one-stick version in 1986, a response by Popsicle Industries to mothers who found the twin Popsicle "messy." Although adults consume 50 percent of all Popsicle products, it seems small children couldn't lick the twin pop fast enough to keep it from dripping. Soon the twin pop will be forgotten, just like Popsicle Pete, the character the Joe Lowe Corporation used to promote the product in the *Popsicle*

Pete Fun Book (1947) and *Popsicle Pete Adventure Book* (1948).

During that same postwar period, Topps kept gum chewers reading with reprints of many Fawcett/DC Comics filler cartoon strips by Henry Boltinoff, Harry Lampert, and other cartoonists. In addition to these reprints, Topps introduced its own characters in the numbered "Bazooka Comic" series. Art Helfant (1898–1971), who drew filler strips for more than a dozen different comic book publishers during the 1940s,

launched the Bazooka Comic series with *Bubbles,* a four-panel strip about a tiny, mustachioed, balding guy in oversized trousers. By Bazooka Comic no. 22, *Bubbles* was replaced with another four-panel strip, *Rollo.* Rollo, a blond, fat kid described as a "sissy" by one of the other kids, soon left in search of more doughnuts. Still fine-tuning by Bazooka Comic no. 31, Topps decided an "Atom Bubble Boy" named Bazooka was the best plan of action to promote the Atom Bubble Gum. In 1949, eighteen million

National/DC Comics readers saw Bazooka (the boy) in a full-page ad series that ran in twenty-nine DC titles. Bazooka (the boy) helped other kids, solved crimes, and captured wrongdoers in aerial antics made possible by blowing giant bubbles. No need to toss out ballast. For a descent, Bazooka (the boy) simply announced the astern phrase "Akoozab! Akoozab! And down I go!" And down he went.

The product was, as Topps touted it in *Chain Store Age,* "an honest nickel's worth for America's kids!" Fondling the

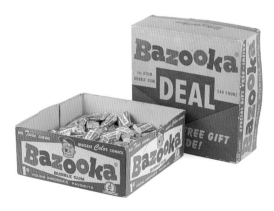

LEFT TO RIGHT: Waxed cardboard counter display, 1950s; plastic counter display, 1950s; Bazooka as it would have appeared in stores in 1958.

crinkly foil wrap of the Atom Bubble Gum, one knew the promised science-fiction future had arrived at last. The "honest nickel" not only brought "6 big chews" but even more adventures of Bazooka (the boy). This Bazooka Comic, large and legible, measured 6 1/2 inches wide by 4 inches deep and had two rows of panels. Beneath each Bazooka Comic were the "Bazooka Riddle" ("What is lighter than a feather yet harder to hold?") and the upside-down answer ("Your breath").

When Bazooka (the boy) blew his last breath into the gum and floated off, vanishing into the clouds to become the bubble gum world's own Amelia Earhart, he had failed to turn "Akoozab" into a national catchword. Perhaps Bazooka (the boy) was too eager, too bland, too nice, too all-American, and maybe not as explosive as one might expect an Atom Bubble Boy to be. At the Topps offices in Brooklyn's Bush Terminal building (a former shipping depot for troop supplies sent to Europe during

World War II), the huge metal doors clanged shut for closed cogitation huddles. When the doors reopened, there stood the wiseacre Bazooka Joe, surrounded by his gang—Jane, Pesty (aka Orville), Pat (aka Li'l Pat), Toughy, Percy, Mort (aka Mortimer), Tex, Mother, Dad, Herman, Sarge, and Walkie-Talkie the Dog.

The man behind both Popsicle Pete and Bazooka Joe was the writer-artist-publisher Woody Gelman, for many years head of product development at

LEFT TO RIGHT: Cherry, original, and grape Bazooka counter display box, 1965; box of sugarless Bazooka, early 1970s; plastic tub of Bazooka featuring art by Howard Cruse, 1980s.

Topps. Born in 1915, Gelman studied at City College, Pratt, and Cooper Union before working on *Popeye* and *Little Lulu* animated shorts. He also contributed to comic books by several publishers, creating funny animal characters for St. John, Fox, Western, Marvel, and Hillman, and was the writer-artist on such four-color features as *Little Richard's Imagination* (1940) for Sangor and *The Kid from Brooklyn* (1944–45) for Eastern. Gelman wrote *Super Mouse* (1944–45) for Pines, and after the war contributed both scripts and layouts to DC Comics for *The Dodo and the Frog*, *Nutsy Squirrel*, and *Gup the Gremlin*.

In the mid-1960s, Gelman also wrote and designed *The Picture History of Charlie Chaplin,* and as the publisher of Nostalgia Press, collected vintage comic book stories and strips into hardcover editions (*Flash Gordon, The Phantom, Mandrake the Magician, Krazy Kat,* and *Little Nemo*, as well as reprints of E.C. Comics). Earlier, during the postwar years, Gelman saw the promotional possibilities of comics characters linked with products, and teamed with the ex-Fleischer/Paramount animator, Ben Solomon, who also worked on a variety of funny animal comic books during the mid-1940s. The offices of Solomon & Gelman Inc. were located in the heart of Manhattan at 247 West 46th Street. As Woody Gelman and Ben Solomon both independently explained it to me, they were off and running with several accounts, including Popsicle and Topps, but then came an ultimatum: They would lose the Topps account unless they worked solely for Topps. So they waved farewell to the Joe Lowe Corporation. (Goodbye, Pete. Hello, Joe, whaddaya know?)

The character of Bazooka Joe was co-created by Woody Gelman and illustrator Wesley Morse. When the first issue of *Circus* (subtitled "The Comic Riot") was published by the Globe Syndicate in June 1938, the lineup of creative talent was a veritable comics pantheon: Basil Wolverton (*Disk Eyes* and *Spacehawk*); Jack Cole (*Peewee Throttle*); Will Eisner (*Jack Hinton*); Bob Kane (*Van Bragger*); and Wesley Morse, represented with his *Beau Gus* feature. The comic was edited by Monte Bourjaily as a showcase of possible syndicated features, but folded after three issues. As the other artists in *Circus* found fame, Morse vanished into obscurity, working in theater and nightclubs outside of comic books. Eventually Gelman tapped Morse for *Bazooka Joe*, having been a fan of his early magazine and newspaper illustration work.

Morse worked in a style not that dissimilar from Gelman's own cartoon roughs (suggesting the possibility that many of the early *Bazooka Joe* strips may have been based on Gelman's layouts). Gags were rewritten from joke books, gag files, and the joke columns of magazines such as *Boys' Life.* Topps staffer Len Brown, the co-creator of the company's *Mars Attacks* card series, did the line editing on *Bazooka Joe* from 1959 to 1964.

The name Bazooka Joe has an origin curiously akin to the name origins of the Fawcett Comics titles and characters. After World War I, W. H. "Captain Billy" Fawcett returned to Robbinsdale, Minnesota, where he began producing a small newsletter of military banter and jokes, circulated among the disabled at the local veterans' hospital. Soon it was distributed by a wholesaler to drugstores and hotel lobbies, where this cartoon and joke publication caught on with its saddle-stitched, digest-size format. The title *Capt. Billy's Whiz Bang* combined Fawcett's name with the nickname of a destructive World War I artillery shell, both of which had been pretty much forgotten by the time the magazine was mentioned in the 1957 song "Trouble" (from Meredith Willson's *The Music Man*). Monthly sales of *Capt. Billy's Whiz Bang* reached half a million, and in 1940 the words in the title were split apart to name the characters and books at Fawcett Comics: *Captain* Marvel, *Billy* Batson, *Whiz* Comics, Slam *Bang*

Comics. Like *Capt. Billy's Whiz Bang,* the title character of the *Bazooka Joe* strip combined the name of Topps head Joe Shorin with the World War II weapon. But there's an earlier pop culture connection—the comedian Bob Burns, aka the Arkansas Traveler. Burns made his radio debut on Rudy Vallee's *The Fleischman Hour,* which aired from 1929 to 1939. After several guest shots with Vallee, Burns joined the Bing Crosby–hosted *Kraft Music*

Hall in 1936, continuing as a featured performer (along with George Murphy and Jerry Lester) for the next five years on this popular NBC musical-variety series. Finally, just as the United States entered World War II, Burns got his own program, *The Bob Burns Show,* in 1941.

One of Burns's gimmicks was a musical instrument constructed of a funnel attached to a gas pipe. He called this a bazooka, and by the end of the thirties, the Burns bazooka had achieved such nationwide fame that the word was adopted for the army's similarly shaped rocket launcher. *Webster's,* in defining the weapon, offers the following as the word origin: "a crude musical instrument made of pipes and a funnel."

Bob Burns Kazooed Bazooka, c. 1940.

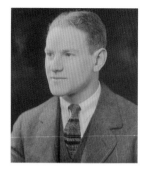

TOP: Joe Shorin, c. 1924.
BOTTOM: "Bazooka Paint with Water,"
activity book, 1983.

When a demonstration of the new rocket gun was held for General Somervell and a group of officers, a captain remarked, "That damn thing looks just like Bob Burns's bazooka!" The observation brought a round of laughter from Somervell and the others, and from that point on, it was always known as a bazooka.

But how did Burns invent his bazooka, and why did he label it with this peculiar word? It all happened on a fateful day in Arkansas over one hundred years ago. In a letter to Charles Earle Funk (published in Funk's 1950 book *Thereby Hangs a Tale),* Burns explained how he coined the word shortly after inventing the instrument: "In 1905 our string band was practicing in back of Hayman's Plumbing Shop in Van Buren, and while we were playing 'Over the Waves' waltz, I broke a string on the mandolin. With nothing else to do, I picked up a piece of gas pipe, inch-and-a-half in diameter and about twenty inches long. And when I blew in one end, I was

very much surprised to get a bass note. Then, kid-like, I rolled up a piece of music and stuck it in the other end of the gas pipe and found that sliding it in and out like a trombone, I could get about three 'fuzzy' bass notes. The laughter that I got encouraged me to have a tin tube made that I could hold on to and slide back and forth inside the inch-and-a-half gas pipe. Later on I soldered a funnel on the end of the tin tube and a wire attached to the funnel to give me a little longer reach. No doubt you have heard the expression 'He blows his bazoo too much.' In Arkansas, that is said of a 'windy' guy who talks too much. Inasmuch as the bazooka is played by the mouth, it's noisy and takes a lot of wind. It just seemed like 'bazoo' fitted in pretty well as part of the name. The affix 'ka' rounded it out and made it sound like the name of a musical instrument—like balalaika and harmonica."

Bubble gum is also played by the mouth, noisy, and takes a lot of wind, so the Topps product, it might be noted, brought much of the original meaning,

as conceived by Burns, back to the word.

Burns was twelve years old when he coined the word "bazooka," and certainly it's an odd quirk of fate that he hit on this at the same time Frank Fleer was stirring up his first batches of Blibber-Blubber. Decades later, the competition between the Fleer Corporation and Topps escalated to such intensity that the rival firms began battling it out in courtrooms to protect their fortunes.

Speaking of fortunes, background on this feature requires yet another journey back in time, since *Bazooka* fortunes have a distinct relationship to fortune cookies. Some chewers divine future events in *Bazooka* fortunes the way others receive oracular instructions from *I Ching* hexagrams, but the bottom line was simply expressed by Woody Gelman: "Kids love fortunes."

In thirteenth-century China, rice paper was inserted inside steam cakes as a means of transmitting messages about civil uprisings (and no doubt secrets were kept by eating the message along with the envelope). Fortune cookies, known in China as *chien ya bing* ("label-speaking cakes"), are believed to have originated in an ancient Chinese parlor game. Chinese immigrant David Jung introduced the label-speaking cakes to the United States shortly after William Wrigley, the man who revolutionized gum advertising, distributed fourteen million of his Mother Goose booklets ("Jack be nimble / Jack be quick / Jack run and get your / Wrigley stick") in 1915–16 "to the children of the world—from 6 to 60." After acquiring every American telephone directory printed in 1915, Wrigley mailed four free sticks of gum to all 1.5 million listings, and tried this trick again in 1919—when the number of phone subscribers had swelled to seven million.

Jung had a more modest advertising budget when he opened his Hong Kong Noodle Company in Los Angeles in 1918 and hired a Presbyterian minister to abbreviate verses from the Bible for cookie insertion. Times have changed. While fortune cookies continue to carry lines like "Opportunity knocks only once," it is possible to find some offbeat one-liners on fortune slips these days, such as "Your friends have a pleasant surprise for you." After dining at a Chinese restaurant back in the 1980s, I cracked a cookie that contained this paradoxical, Philip K. Dick–like dictate: "Destroy this fortune before reading it."

It's easy to envision Woody Gelman conjuring up the concept of *Bazooka* fortunes while sitting in a Chinese restaurant, although no one recalls this historic moment from 1953. The contemporary connection between Bazooka and fortune cookies is by cartoonist Mark Newgarden. Before his Topps tenure, Newgarden wrote funny fortunes in 1977–78 for the Goldberg Fortune Cookie Company. His gags for Goldberg were distributed to stores in a Milton Glaser–designed package.

The *Bazooka* fortune that reads "Help! I'm a prisoner in a bubble gum factory!" was among the batch I wrote for Topps back in 1972. In November

1987, a young woman in Los Angeles opened a piece of Bazooka gum, read the fortune, and became concerned about this desperate plea. Distressed, she picked up the telephone and dialed the Topps offices. The switchboard operator passed the call on to Newgarden, who somehow managed to calm the woman and assure her that no *Bazooka* fortune writers were chained and shackled in the sublevels of Topps.

Coincidentally, there's another food product with a "Joe" character. Little Joe, grits dispensed by the Northern Illinois Cereal Company in 1930, used an illustration of a kid wearing a tie about to dig into his bowl of grits. But Little Joe's only resemblance to Bazooka Joe is the tuft of hair over the forehead. It's more probable that Gelman and Morse were influenced by the kids in Ad Carter's *Just Kids* comic strip (1923–57) and Gene Byrnes's memorable *Reg'lar Fellers* (1917–49). By the 1940s, the Byrnes strip had reached such peaks of popularity that his kid gang stepped in

as summer replacements for Jack Benny with the 1941 *Reg'lar Fellers* radio show and then, armed with wooden swords, marched through backyards to spread World War II propaganda in the hardback *Reg'lar Fellers in the Army* (Brockway, 1943). This book, highly prized by youngsters in the mid-1940s, interspersed color comics with black-and-white combat photographs.

Reg'lar Fellers, the *Our Gang* comedies of Hal Roach, and *Bazooka Joe* all have dog characters in supporting roles. The ubiquitous dog with a ring around its eye can probably be traced back to silent-film comedies, and one obvious forerunner from that same period is Bingo, the pooch seen with Jack the Sailor Boy on Cracker Jack boxes. When the boy and his dog first appeared on the boxes during World War I, Jack was modeled after the grandson of Cracker Jack founder Frederick William Rueckheim, and the dog was inspired by a children's song with a line about a pet dog (". . . and Bingo was his name-o").

Rueckheim's grandson died of pneumonia at the age of eight, and the sailor boy trademark became Rueckheim's own personal Rosebud. If you go to St. Henry's Cemetery in Chicago, you can see the image of Jack the Sailor Boy engraved on his tombstone.

Reg'lar Fellers featured Bullseye the Dog, and the tradition of a dog with a ring around its eye continued in *Bazooka Joe* with Walkie-Talkie. The *Reg'lar Fellers* radio show cast included an actor named Orville Phillips, and a character named Orville (aka Pesty) turned up in the *Bazooka Joe* lineup. There are also links between *Fleer Funnies* and *Reg'lar Fellers.* Pud, the star of *Fleer Funnies,* is a fat kid who wears a red-and-white-striped V-neck sweater, while the Byrnes strip not only featured a plump kid in a red-and-white-striped V-neck sweater, it also had another character named Puddinhead.

Reputed Dubble Bubble inventor Walter Diemer (who remained on the Fleer board of directors after his 1970 retirement), stated that *Fleer Funnies*

became an addition to the Dubble Bubble package "to make our product distinctive" from imitations (which appeared within three months after Dubble Bubble was first marketed during the Christmas holidays of 1928). Yet today, some people still get the characters of *Fleer Funnies* confused with the *Bazooka Joe* gang. Perhaps it's because they both inhabit reduced-scale worlds of similarly shaped paper ephemera, deftly described by Richard Meltzer in his critique of "two-dimensional visual amusement" titled "It All Started with Pud" (in Frank Lunney's *Syndrome* no. 3 from 1973).

Unlike trading cards, notes Meltzer, bubble gum funnies had a throwaway aspect, but "everybody but everybody came in contact with Pud." Bubble gum funnies provided a common denominator, a Prairie City where we all lived—only it wasn't a city: "Pud's place was rural, semi-rural, suburban, semi-urban, anything. It just wasn't a real hardcore city, that's the only thing it wasn't as far

as mere geographical abstraction goes." Tiny rectangles inside rectangular counter display boxes, around the corner at the corner store, and from these rectangles one grew up and expanded geometrically, as Meltzer visualized it.

Wesley Morse lived in this world of rectangles. During the 1950s, Morse filled

in one *Bazooka Joe* panel after another through the last eight years of his life. When Morse died, he was not replaced until decades later. Kids grow up, creating a continual turnover among consumers, so it was decreed by Topps management that the seven-year backlog of strips was sufficient. *Bazooka Joe* went into reruns,

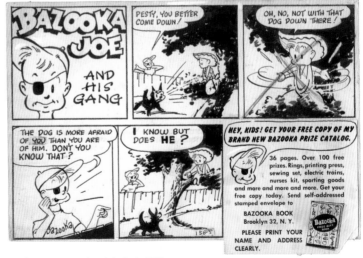

Wesley Morse Bazooka original art, 1956.

and the Morse output was recycled for the next generation and even the next. In truth, Topps never needed seven years of *Bazooka Joe.* The stockpile accrued because of Gelman's generosity; he continued to generate the assignments for Morse because he knew he needed the work. During that period, Morse released two to three series of *Bazooka Joe* strips a year until his death in 1963.

Few facts about Morse are available. He drew chorus girl cartoons, and the female figures he rendered in *Beau Gus* certainly indicate his anatomical aptitude. He also worked for a New York newspaper, and one source suggests this was Bernarr Macfadden's *New York Graphic* (1924–32), famed for its use of

"composographs"—composite photos of posed models and real people (speaking dialogue in hand-lettered balloons), created by the *Graphic*'s Harry Grogin to depict unphotographed news events. However, there's no mention of Morse in Lester Cohen's *The New York Graphic— The World's Zaniest Newspaper* (Chilton, 1964). And since no one is giving out grants for dissertations on the aesthetics and creators of bubble gum funnies, the details of Morse's life remain a research problem.

What is known is that Morse played a key role in the *true* underground of American cartooning—the eight-pagers (aka Tijuana Bibles) of the 1930s. According to Donald H. Gilmore in his four-volume *Sex in Comics* study (Greenleaf, 1971), "there were apparently only twelve artists involved in the vast majority" of the more than seven hundred different eight-page erotic comics created between 1930 and the early 1950s.

Morse, so said some who knew him, was one of the original Tijuana Dozen;

the others in the group have managed to remain anonymous. These artists delighted in putting famous syndicated comic strip characters in the bedroom, yet after the 1952 debut of *MAD* and its comic strip satires, the eight-pagers became antiquated artifacts, a transition hinted at by Harvey Kurtzman on his "Comics Go Underground" cover of *MAD* no. 16 (October 1954). The second panel shows "a comic-book publisher, whose books have been banned from the newsstands, secretly peddling his comics on a busy street corner" and in the first panel, a "Comic-Book Raid," a drawing highly reminiscent of the 1935–39 raids and seizures at the eight-pager warehouses. Foreshadowing the end of the eight-page movement was a 1950 *Dragnet* radio episode in which Joe Friday (Jack Webb) and Sergeant Ben Romero (Barton Yarborough) discover that a Holy Bible printing plant is actually a front for the publication of Tijuana Bibles.

In 1983, Topps decided to update and modernize *Bazooka Joe* with about

forty new strips drawn by cartoonist Howard Cruse (*Stuck Rubber Baby*). So the character grew up and became a teenager. Rock bands, video games, and other topical references were added in new gags submitted by Cruse, Newgarden, Peter Bagge (*Hate, Neat Stuff*), J. D. King (*Twist*), Jay Lynch (*Bijou, Wacky Packages*), and John Holmstrom (*Punk, High Times*). Filmmaker and *Blondie* comic strip writer Chris Hart, son of longtime Topps contributor Stan Hart (scripter for *MAD* and *The Carol Burnett Show*), also wrote gags for the *Joe* revamp. "The problem with doing these *Bazooka Joe* gags," recalled Cruse, "was that you couldn't have any continuity—each one had to be drawn as if it might be the first anyone had ever seen. You couldn't have any running gags. The only direction I was given was that this guy was now a teenager."

OPPOSITE: Cover from a Wesley Morse Tijuana Bible, c. 1939.
RIGHT: Howard Cruse Bazooka Joe model sheet for 1983 revamp.

BAZOOKA JOE

JOE'S AN AVERAGE TEENAGER WITH A PENCHANT FOR WISE-CRACKS WHO WORKS THREE AFTERNOONS A WEEK AT A FAST FOOD RESTAURANT. HE'S INTERESTED IN GIRLS, CARS, BIKES AND VIDEO GAMES. HE'S A FAIRLY INDUSTRIOUS HIGH SCHOOL STUDENT, THOUGH HE DOES USE STUDY HALLS TO DREAM UP NEW SONGS FOR HIS ROCK BAND TO PERFORM.

VAL

VAL IS JOE'S LONGTIME GIRLFRIEND, THOUGH THEY HAVEN'T WORKED UP TO 'GOING STEADY' YET. SHE'S A WHIZ WITH COMPUTERS, KNOWS CARS INSIDE OUT, AND PLAYS DRUMS IN JOE'S BAND. SHE'D LIKE TO BE AN ASTRONAUT WHEN SHE GROWS UP IF IT WON'T TAKE TOO MUCH TIME AWAY FROM HER CAREER.

MR. MARTIN

MR. MARTIN TEACHES BAZOOKA JOE AND HIS GANG IN HIGH SCHOOL. A DEDICATED EDUCATOR AND INDEFATIGABLE PEDAGOGUE, HE BEGAN COLLEGE AS A ZOOKEEPING MAJOR, THEN TRANSFERRED INTO SECONDARY EDUCATION OUT OF A HUMANITARIAN IMPULSE. HE HAS RESOLVED NEVER TO ACT ON IMPULSE AGAIN.

"SHADES" SPIKE & BLOTCH

SPIKE IS A LONER WHO DIVERTS ATTENTION FROM HIS INSECURITIES BY BEING RELENTLESSLY OBNOXIOUS. HE THINKS VAL IS WASTING HER TIME WITH BAZOOKA JOE AND SHOULD OPT FOR LIFE IN THE FAST LANE WITH HIM. HIS DOG BLOTCH DIGS PUNK MUSIC AND LIKES TO SLAM DANCE WITH THE POODLES IN THE WAITING ROOM OF THE VETERINARY CLINIC.

RED

A GENIAL SLOB AND COMPULSIVE COLLECTOR OF COMICS, CARDS, AND OLD MOVIE TRIVIA, RED IS A NICE GUY WHOSE BRAIN GOT INSTALLED WITH LOOSE CONNECTIONS. WHENEVER HE SEES A LINE OF PEOPLE HE STANDS AT THE END OF IT, FIGURING THEY MUST BE WAITING FOR SOMETHING INTERESTING. HE ONCE GOT IN TROUBLE FOR QUEUING UP BEHIND THE ROCKETTES ONSTAGE AT RADIO CITY MUSIC HALL.

BAZOOKA JANE & PAWS

JANE IS BAZOOKA JOE'S LITTLE SISTER, TEN YEARS OLD AND SMART AS A TACK. SHE FUNNELS HER ALLOWANCE INTO THE STOCK MARKET AND ADVISES CORPORATION EXECS ON MAJOR MERGERS. JANE IDOLIZES BAZOOKA JOE BUT THINKS HIS AMBITION LACKS FOCUS. HER CAT PAWS' LIKES PURRING, LAPPING MILK AND CHEWING BUGS.

ROBIN

SHE'S VAL'S BEST FRIEND — SENTIMENTAL, ROMANTIC, AND A MESS. SHE'S ALWAYS BUYING SELF-HELP BOOKS IN HOPES OF OVERHAULING HER PERSONALITY SO THAT SHE CAN WIN FRIENDS, ATTRACT BOYS, BE A SELF-ASSERTIVE CAREER WOMAN AND HAVE HAIR THAT CURLS THE WAY BROOKE SHIELDS'S DOES.

Earlier he had been some little pip-squeak age. They presented me with a set of characters and said, 'Create an image.' They gave me samples of the old strip with all the characters as kids, and they said, 'The main thing is: He has to have his eye patch.' The punkiest thing was that character who has black sunglasses and spikey hair. He looks sort of like a variation on that obnoxious guy in *Buzzy Comics*. Some of the characters were totally new. I think there were about eight or nine characters that they got me to do model sheets on, and then they sent them out to these various gag writers. The character Bazooka Joe doesn't have an opportunity to develop any kind of distinctive personality because each gag has to stand one hundred percent on its own."

At one time or another, you've probably asked yourself, "Hey! What's the deal with Bazooka Joe's eye patch?

OPPOSITE: Howard Cruse Bazooka Joe model sheets for 1983 revamp.

Can he see okay?" The answer is yes. "He's really got twenty-twenty vision in both eyes," said former Topps president Joel Shorin. To trace this one, we have to go all the way back to 1947 when Harold Rudolph wrote a book titled *Attention and Interest Factors in Advertising.* One of Rudolph's notions was that photos with story elements grab attention, and advertising man David Ogilvy remembered this passage from Rudolph's book while creating ads for Hathaway Shirts during the mid-fifties. Ogilvy put an eyepatch on model Baron George Wrangell, and the Hathaway Shirt man became one of the most famous ad campaigns of the decade. To satirize the Hathaway ads, Woody Gelman asked Wesley Morse to put an eye patch on Joe. Yes, it was that simple, folks. And it makes perfect sense. For a kid, Joe's eye patch *is* an attention getter and interest factor, and so is the turtleneck covering the lower half of Mort's face. In fact, these are the most memorable aspects of the strip.

Just as people who have not seen an E.C. horror comic in thirty-five years can summon up a memory of the Old Witch while forgetting the specifics of any E.C. horror story, former gum chewers who haven't opened a piece of bubble gum in decades can usually remember Mort's odd apparel. The gags are forgettable, but Mort's sweater is not. Strange then that this distinctive feature was eliminated in the 1983 revamp. This parallels the 1974 *Wonder Woman* made-for-TV movie in which Cathy Lee Crosby (as Wonder Woman) was costumed in star-studded sleeves and a plain minidress. The audience only knew this was Wonder Woman when someone said, "Hey, Wonder Woman!"

Bazooka Joe can be found in other Topps products apart from Bazooka gum. It was included in the Bazooka lollipop series along with other one-panel gags scripted by Lynch, Art Spiegelman (*Maus*), and Newgarden; the Cruse illustrations for that product appeared not in an insert but on the

wrapper itself. For the *Funny Li'l Joke Books* series (1970), written by Spiegelman, Lynch, and myself, with illustrations by Tom Sutton and others, Bazooka Joe put in a cameo appearance. And the character graduated to the bubble gum equivalent of prime time when *Bazooka Joe* trading cards became part of the twenty-five-cent Big Bazooka package in the early 1970s.

A musical homage to the character came during the 1970s with the British rock group named Bazooka Joe. This college-based band would be largely forgotten today were it not for the fact that 1) they introduced the Sex Pistols (in their first performance on November 6, 1975), and 2) one of the Bazooka Joe members was Stuart Goddard, who later became singer Adam Ant. Another group to appropriate the name during the mid-1970s was the Bazooka Gang, contributors of anarchic art to the pages of the French magazine *Metal Hurlant*.

And, of course, there are also satires on *Bazooka Joe,* including *Bazonga Joe,* credited to Al Andrien in the *National Lampoon's Very Large Book of Comical Funnies* (1975). Escape Publishing was responsible for the Reet Petite Postcard Set, with "Johnny Tomorrow," "Mr. Potato Head," "Man with X-ray Eyes," and "Lil Elvis" all drawn by Shaky Kane in the *Bazooka Joe* format. Cartoonist Ron Barrett, best known for his "Politenessman" strip in *National Lampoon* and the classic children's book *Cloudy with a Chance of Meatballs,* illustrated Topps's *Wacky Packages Album,* and he also satirized *Bazooka Joe* for both the *Lampoon* and a non-Topps postcard series. Topps published its own parodies of Bazooka—"Gadzooka," a sticker in *Wacky Packages* (Series 1, 1973); "Joe Blow/Rod Wad," in *Garbage Pail Kids* (Series 3, 1986); and "Bazooka Jerk" (spokesman for "Flopps Gum, Inc."), in the *Garbage Pail Kids Giant Series* (1986)*,* written by Newgarden and Spiegelman. "Bazooka Jerk" was illustrated by Garbage Pail Kids artist Tom Bunk, who came to this country in 1984.

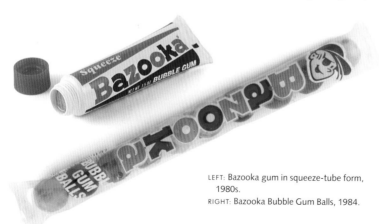

LEFT: Bazooka gum in squeeze-tube form, 1980s.
RIGHT: Bazooka Bubble Gum Balls, 1984.

Bunk was well known in Germany, where he cartooned for *Pardon,* the German equivalent of *National Lampoon*.

Most of the satiric jabs at Joe have been delivered by Newgarden, dating back to "Mort and His Emotional Disturbances," written and drawn in the *Bazooka Joe* format for the *East Village Eye* (1983) and later reprinted in *Bad News* no. 2 (1984), coedited by Newgarden with Paul Karasik. Next came Newgarden's "Sad But True" (*High Times*, January 1985): "1982 autopsies revealed Mort's digestive system absorbed over 4 oz. of Red Dye #3, apparently ingested from casual sportswear over a 30-year period." For the four-page "Love's Savage Fury" (*Raw* no. 8, 1986), Newgarden took the following personal ad from the "Voice Bulletin Board" on the back cover of the *Village Voice*: "I saw you on the subway but I forgot what you looked like. I smiled. You ignored me. Send photo." He then illustrated this ad with panels showing Bazooka Joe staring at Ernie Bushmiller's Nancy in a subway car.

Bazooka Joe blows a bubble as he says to Nancy, "I want to see you again. In case I forget what you look like!" Then the bubble explodes, leaving his face, cap, and speech balloon covered with bubble gum. On pages two and three, Nancy also explodes, in his memory, and he returns on page four to take a Polaroid of Nancy.

Satires and revamps aside, Joe will endure. How do I know? Because even though its arguable where he falls on the pop culture ladder, discarded behind piles of paper ephemera in the basement of the mind, one can nevertheless hear the slow but steady footfalls of the fanboys. Yes, even as we speak, a fandom is looming out of the shadows, gathering for a march past the picket fences of Prairie City. Between the gum and the graffiti on the wall, fans search for cards, stickers, wrappers, and maybe even chewed gum in Les Davis's magazine of non-sports trading cards, *The Wrapper*, first published in 1978, and Roxanne Toser's *Non-Sport Update*, a bimonthly magazine for collectors,

which has been providing pop culture addicts their trading card history fix since 1990.

There are even non-sports conventions, the first one held at a Holiday Inn in Parsippany, New Jersey, in August 1987. Since then these shows have been held at hotels and convention centers all over the country.

Where will all this end? Who knows. But where will this article end? Right here in this paragraph. For a parting shot, I'll leave you with this small anagrammatic oddity: Change two letters in Bazooka Joe's name and you've got the name of one of the most successful newspaper strip characters of the 1940s and '50s—Joe Palooka. What does that mean? I don't know. So don't ask.

Okay, that's a wrap.

BHOB STEWART is a writer, editor, cartoonist, and filmmaker who has contributed to a variety of publications over a span of five decades.

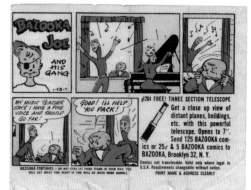

LEFT TO RIGHT, TOP TO BOTTOM: 1955, 1957, 1957, 1958

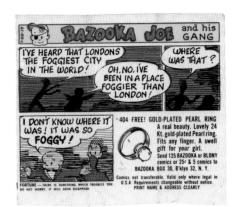

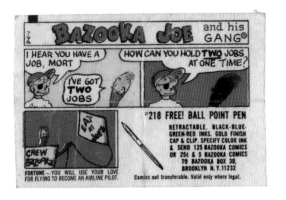

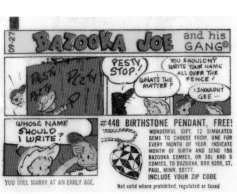

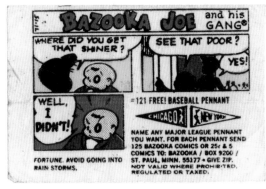

LEFT TO RIGHT, TOP TO BOTTOM: 1960, 1964, 1969, 1971

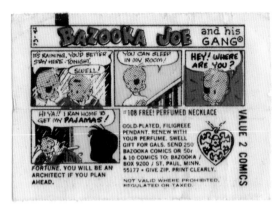

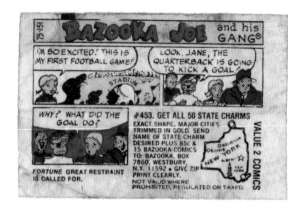

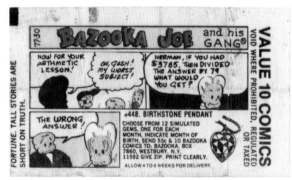

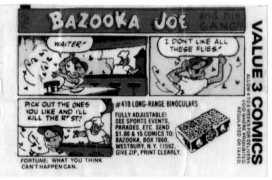

LEFT TO RIGHT, TOP TO BOTTOM: 1973, 1975, 1977, 1979
OPPOSITE: Original art for cigar store Indian–themed sell sheet, 1970s.

FLOP
←

DU PONT

Topps ª 285
4³/₄ to 6–126%
FLOP
B Outline

Ⓐ

THE COPY
FLOPPED + STRIPPED INTO
POSITION AS INDICATED ON

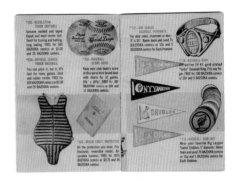

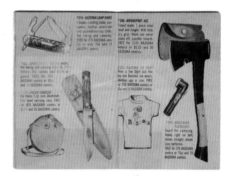

and insignia. 3" diameter. Name
team and send 75 BAZOOKA
comics OR 15¢ and 5 BAZOOKA
comics for each emblem to BAZOOKA, Dept. 14,
Brooklyn 32, N. Y.
PLEASE PRINT NAME AND ADDRESS CLEARLY
(Not valid where contrary to state laws. Offer expires June 30, 1956.)

AVE Bazooka COMICS FOR FREE PRIZES

EY, KIDS! GET YOUR FREE COPY OF MY
RAND NEW BAZOOKA PRIZE CATALOG.

BOYS! GIRLS! 36 pages in color. Hundreds of FREE prizes for boys and girls. Electric Trains, Sporting Goods, Shelby Bicycles. Get your free copy today. Important, send no money — just a <u>SELF-ADDRESSED, STAMPED</u> envelope to:
BAZOOKA BOOK
Brooklyn 32, N. Y.

THESE PENNANTS MAKE MY ROOM LOOK KEEN!

I ♥ NY YANKEES

Bazooka Free Gift Book prize catalog, 1955.

OPPOSITE: Front and back cover.
LEFT: Inner wax wrapper ad for the catalog.
ABOVE: Interior pages.

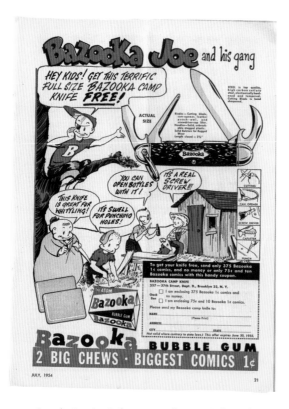

ABOVE: Bazooka Camping Knife magazine advertisement from July 1954 (left) and accompanying letter from Topps (right).
OPPOSITE TOP: Bazooka Camping Knife premium and gum comic ad, 1950s.
OPPOSITE BOTTOM: Camera premium and gum comic ad, 1950s.

#219 FREE BAZOOKA CAMP KNIFE

Free! A genuine camp knife with 4 blades — cutting blade, can-opener, leather punch-awl and screwdriver cap-lifter. Full size 3½" Just the thing for hiking and camping. Get this swell knife free for only 375 BAZOOKA comics and no money or send 75¢ and 10 BAZOOKA comics to BAZOOKA, Dept. 26, Box 20, Brooklyn 32, N. Y. (Not valid when contrary to state laws. Offer expires June 30, 1955.)

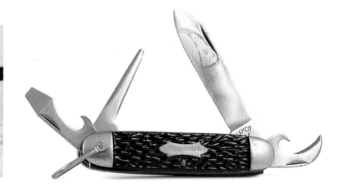

#400 FREE! REAL CAMERA
Takes 16 photos to each roll #127 film. Prints can be enlarged. With instructions. Year-round fun. Send 250 BAZOOKA or BLONY comics or 50¢ & 10 comics to BAZOOKA, Box 30, B'klyn 32, N. Y.

Comics not transferable. Valid only where legal in U.S.A. Premium values changeable without notice. PRINT NAME AND ADDRESS CLEARLY.

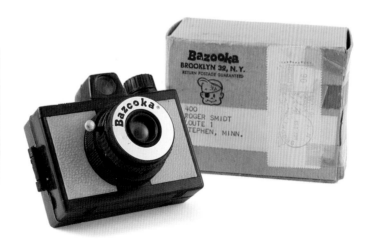

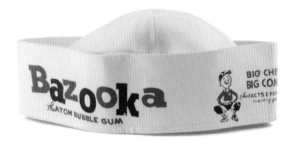

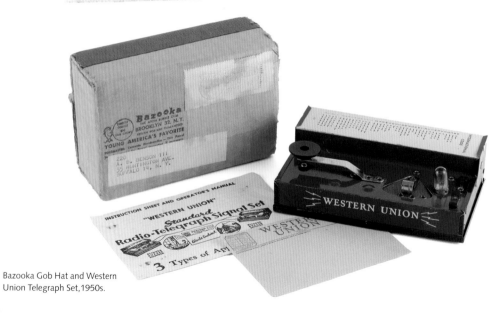

Bazooka Gob Hat and Western
Union Telegraph Set, 1950s.

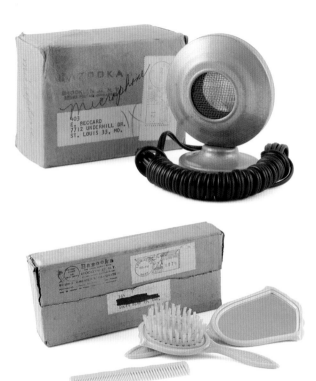

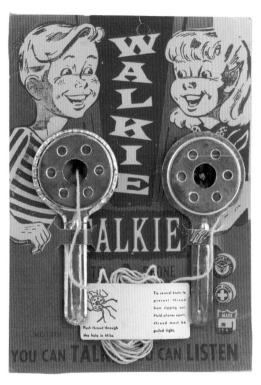

Microphone, Vanity Set, and Walkie Talkie, 1950s.

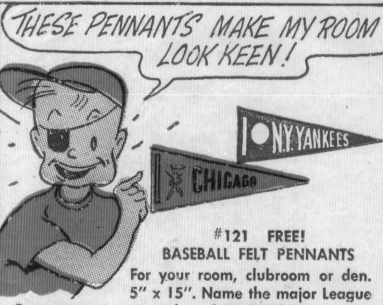

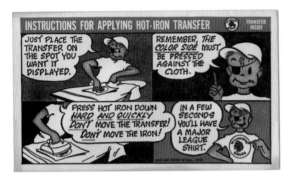

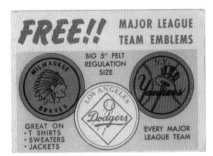

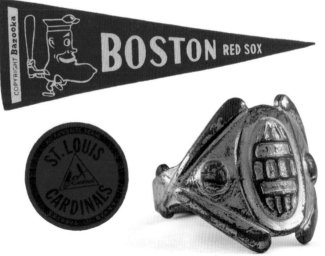

OPPOSITE: Baseball Felt Pennants inner wax wrapper ad, 1950s; and Baseball Ring inner wax wrapper ad, c. 1949.

ABOVE: Hot-Iron Transfer comic envelope and Boston Red Sox and Baltimore Orioles transfers, 1950s; Major League Team Emblems envelope and St. Louis Cardinals emblem, 1950s; Boston Red Sox pennant, 1950s; and Baseball Ring premium, c. 1949.

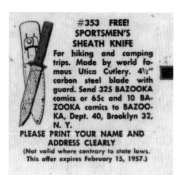

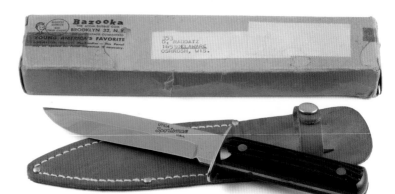

#353 FREE!
SPORTSMEN'S
SHEATH KNIFE
For hiking and camping trips. Made by world famous Utica Cutlery. 4½" carbon steel blade with guard. Send 325 BAZOOKA comics or 65c and 10 BAZOOKA comics to BAZOOKA, Dept. 40, Brooklyn 32, N. Y.
PLEASE PRINT YOUR NAME AND ADDRESS CLEARLY
(Not valid where contrary to state laws. This offer expires February 15, 1957.)

FIRE 1...FIRE 2...FIRE 3
GET YOUR EXPLODING BATTLESHIP
with submarine and 3 torpedoes
FREE FOR BAZOOKA COMICS!

A DIRECT HIT HERE 'EXPLODES' THE SHIP!
• REAL-LOOK N' SCALE MODELS!
• COMPLETELY SAFE - INDOORS OR OUT!

THIS COUPON IS WORTH ONE BAZOOKA COMIC FOR FREE PRIZES.

Get this sea-raiding submarine with three torpedoes and a battleship that explodes when you score a direct hit! A real test of skill. Easy to assemble. Use it over and over again.

Send only 175 BAZOOKA comics for your FREE Battleship or 35c and 5 comics, to BAZOOKA BATTLESHIP, P.O. BOX 2950, ST. PAUL, MINNESOTA. Specify #437 when ordering. Print your name and return address clearly.

Comics not transferable. Valid only where legal in U.S.A. Requirements changeable without notice

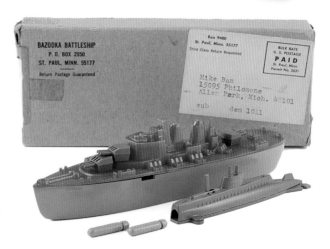

Sportsmen's Sheath Knife premium and gum comic ad, 1950s;
Exploding Battleship and ad, 1960s.

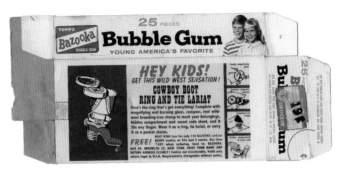

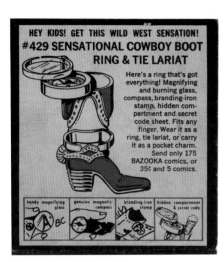

HEY KIDS! GET THIS WILD WEST SENSATION!
#429 SENSATIONAL COWBOY BOOT
RING & TIE LARIAT

Here's a ring that's got everything! Magnifying and burning glass, compass, branding-iron stamp, hidden compartment and secret code sheet. Fits any finger. Wear it as a ring, tie lariat, or carry it as a pocket charm. Send only 175 BAZOOKA comics, or 35¢ and 5 comics.

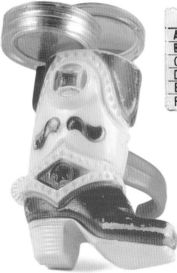

Cowboy Boot Ring and Tie Lariat premium with secret code sheet, ad from prize catalog, and bubble gum box with ad, 1960s.

143

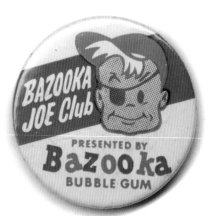

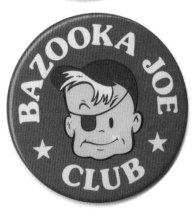

Bazooka BUBBLE GUM

YOUNG AMERICA'S FAVORITE

254-36th STREET, BROOKLYN 32, NEW YORK

Dear Club Member:

Welcome to the Bazooka Joe Magic Circle Club! Glad to have you aboard.

Enclosed with this letter are your Club Membership Card with the Secret Magic Circle Code on the back; your Club Membership Certificate; and, of course, your very own initialled Club Ring.

As a Charter Lifetime Member, you are entitled to:

Wear your special Membership Initial Ring. There's a picture of me, Bazooka Joe, on the ring. It shows all your friends that you belong to my Magic Circle Club. The top is removable, and there's a stamp pad inside with your initial. It's perfect for "signing" mysterious messages, and writing to friends and other Club Members. When the stamp pad runs dry, wet it with any type of ink and you'll be able to use it over and over again. But be careful when you re-ink the pad to avoid getting ink on your clothes or furniture.

Carry your Lifetime Membership Card and use the Magic Circle Code on the back. Your Membership Card is official proof that you are a member in good standing of the Bazooka Joe Magic Circle Club. The Magic Circle Code shows you how to write and de-code secret letters. Only Club Members know this code. Don't let anyone else ever see it.

Display your Official Charter Membership Certificate in your room or paste it in your notebook. Wherever you put it, display it proudly.

Now here's your first chance to use the Secret Magic Circle Code:

Bazooka Joe

BAZOOKA JOE, NATIONAL CLUB PRESIDENT

BIG TWIN CHEWS FRUIT SUNDAE FLAVOR

FULL COLOR COMICS

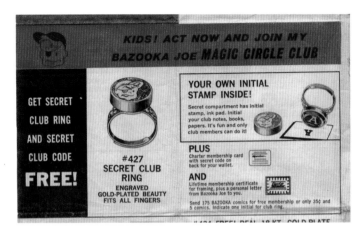

KIDS! ACT NOW AND JOIN MY
BAZOOKA JOE **MAGIC CIRCLE CLUB**

GET SECRET
CLUB RING
AND SECRET
CLUB CODE
FREE!

**#427
SECRET CLUB
RING**
ENGRAVED
GOLD-PLATED BEAUTY
FITS ALL FINGERS

**YOUR OWN INITIAL
STAMP INSIDE!**

Secret compartment has initial
stamp, ink pad. Initial
your club notes, books,
papers. It's fun and only
club members can do it!

PLUS
Charter membership card
with secret code on
back for your wallet.

AND
Lifetime membership certificate
for framing, plus a personal letter
from Bazooka Joe to you.

Send 175 BAZOOKA comics for free membership or only 35¢ and
5 comics. Indicate one initial for club ring.

Hi ____

Here is your special
Bazooka Joe Imprint Ring

Have Fun

Your Friend
Bazooka Joe

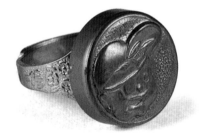

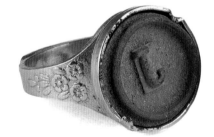

OPPOSITE LEFT: U.S. and U.K. Bazooka Joe Magic Circle Club buttons, 1960s.
OPPOSITE RIGHT: Bazooka Joe Magic Circle Club welcome letter, 1960s.
ABOVE: Bazooka Joe Magic Circle Club Initial Ring, ad from prize catalog,
 and personalized letter from Bazooka Joe, 1960s.

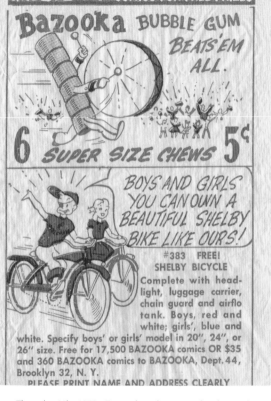

Throughout the 1950s, Topps released a variety of trading cards. Packs would have an exterior wrapper, and then an inner wax wrapper used for advertising Bazooka premiums.

Read about JANET in **Bazooka** *Comics*
She's Bazooka Joe's favorite girl—and no wonder!

BUTCH *Says:*

OH, SAY, CAN YOU SEE WHAT I SEE? YOU'RE MISSING PLENTY IF YOU HAVEN'T GOT ONE OF THESE POWERFUL TELESCOPES!

Read about BUTCH in **Bazooka** *Comics*
He'd lick his weight in wildcats—if he had any!

Read about BUTCH in **Bazooka** *Comics*
He'd lick his weight in wildcats—if he had any!

HUNGRY HERMAN *Says:*

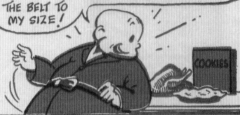

OH, BOY! WITH THIS TERRIFIC WESTERN BELT I'VE GOT NOTHING TO WORRY ABOUT NO MATTER HOW MUCH I EAT, I CAN ADJUST THE BELT TO MY SIZE!

COOKIES

Read about HUNGRY HERMAN in **Bazooka** *Comics*
He eats only one meal a day—from morning to night!

BAZOOKA JOE *Says:*

147

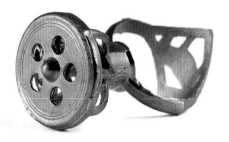

KIDS! ACT NOW AND
JOIN MY BAZOOKA JOE
MAGIC CIRCLE CLUB

GET SECRET CLUB RING & SECRET CLUB CODE FREE!
THIS COUPON IS WORTH 1 BAZOOKA COMIC FOR FREE PRIZES!

SECRET CLUB RING!
ENGRAVED
GOLD-PLATED BEAUTY
FITS ALL FINGERS

YOUR OWN INITIAL STAMP INSIDE!
SECRET COMPARTMENT HAS INITIAL STAMP,
INK PAD, INITIAL YOUR CLUB NOTES, BOOKS,
PAPERS. IT'S FUN AND ONLY
CLUB MEMBERS CAN DO IT

PLUS! CHARTER MEMBER CARD WITH
SECRET CODE FOR YOUR WALLET
CERTIFICATE FOR FRAMING

HERE'S HOW TO JOIN...
SEND 175 BAZOOKA AND/OR BLONY COMICS
FOR FREE MEMBERSHIP OR ONLY 35¢ AND
5 COMICS TO BAZOOKA JOE CLUB, BOX 77
B'KLYN, 32, N.Y. INDICATE ONE INITIAL FOR
CLUB RING. **SEND NOW AND BE A CHARTER
MEMBER!** Comics not transferable. Valid only where legal in
U.S.A. Requirements changeable without notice.

Join the
BAZOOKA JOE
MAGIC CIRCLE
CLUB

and get your
MEMBERSHIP
CARD,

Member

SIREN
RING

Confidential

and the Secret
SIREN CODE

Details overleaf

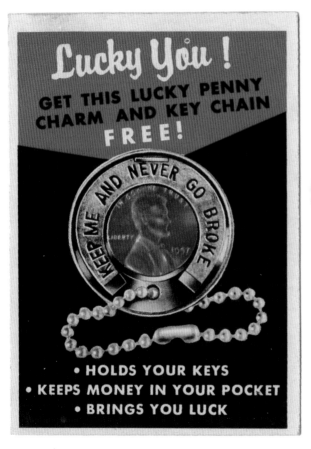

Lucky You !

GET THIS LUCKY PENNY CHARM AND KEY CHAIN FREE!

KEEP ME AND NEVER GO BROKE

- HOLDS YOUR KEYS
- KEEPS MONEY IN YOUR POCKET
- BRINGS YOU LUCK

OPPOSITE: Bazooka Joe Magic Circle Club Siren Ring and premium ads, 1960s.

ABOVE: Bazooka-Blony Lucky Penny Charm and Key Chain, and insert card found in various Topps trading card packs, 1957.

149

1955

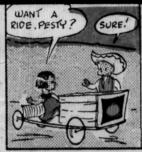

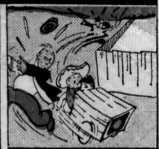

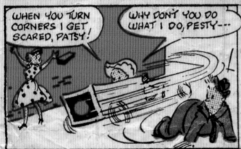

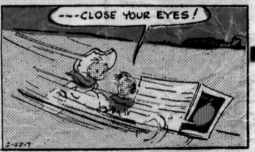

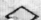

BAZOOKA FORTUNES — YOU ARE DESTINED TO HAVE GREAT RICHES AND HONOR, MAINLY BECAUSE OF THE FINE POWER OF YOUR THINKING.

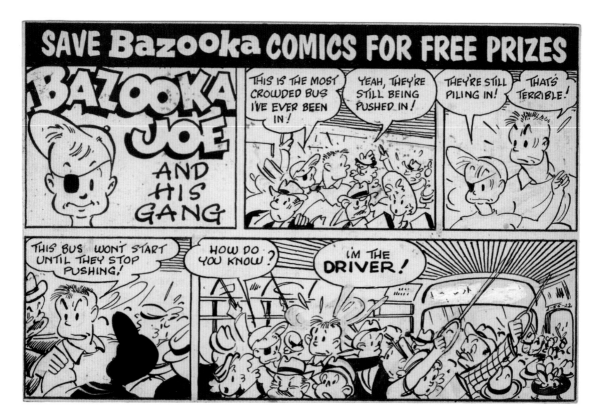

1955

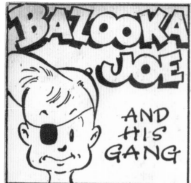
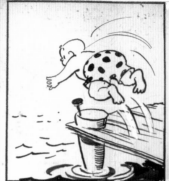
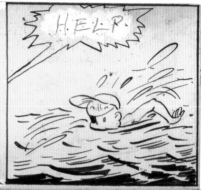
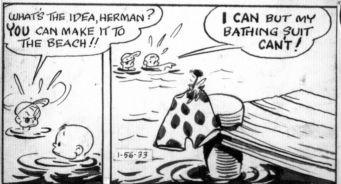

1956

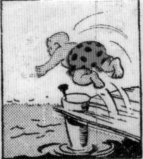

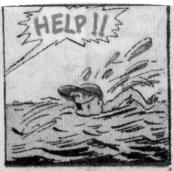

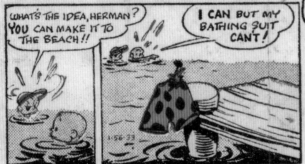

BAZOOKA FORTUNES — YOU ARE A DARE-DEVIL, ALWAYS WILLING TO TAKE A CHANCE. TO ACHIEVE SUCCESS YOU MUST DEVELOP YOUR MIND.

155

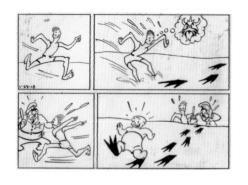

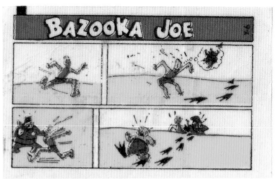

TOP: International pantomime, 1959.
BOTTOM: International pantomime, c. 1960.

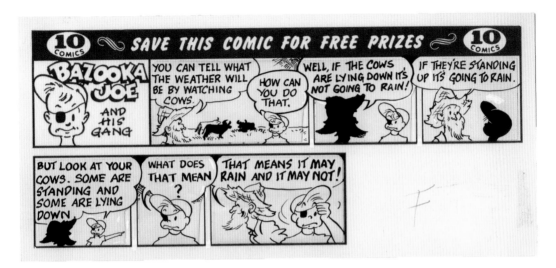

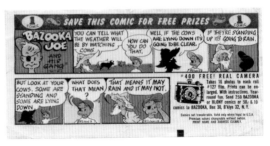

Original art, color guide, and finished comic, 1961.

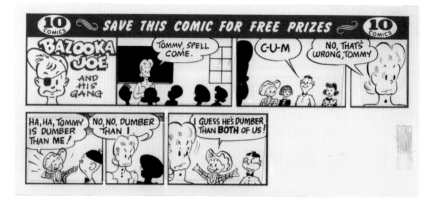

Original art and color guide, c. 1961.

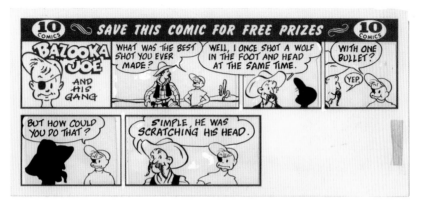

Original art and color guide, 1961.

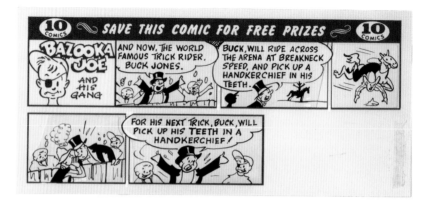

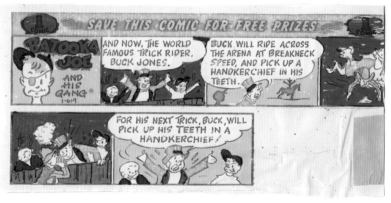

Original art and color guide, 1961.

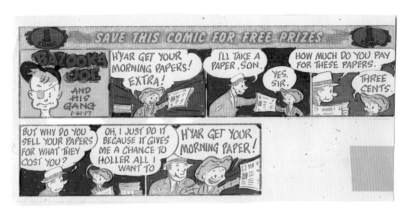

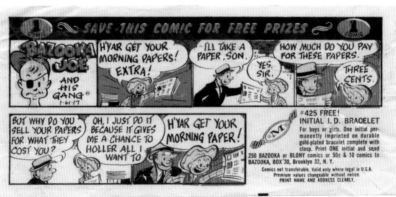

Color guide and finished comic, 1961.

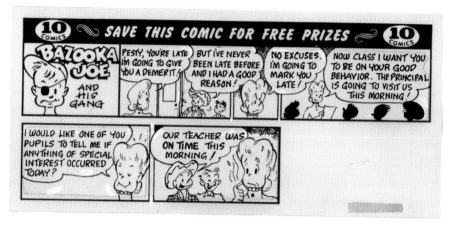

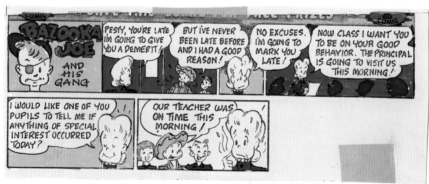

Original art and color guide, c. 1961.

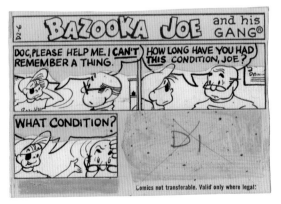

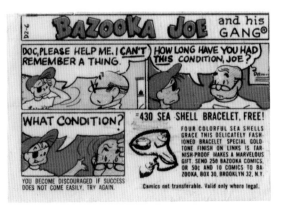

1962

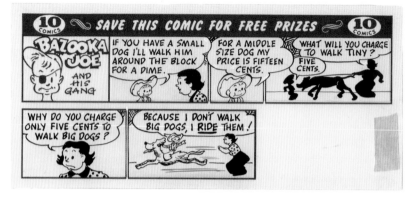

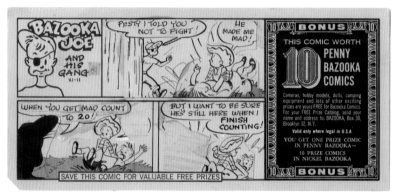

TOP: C. 1961
BOTTOM: 1962

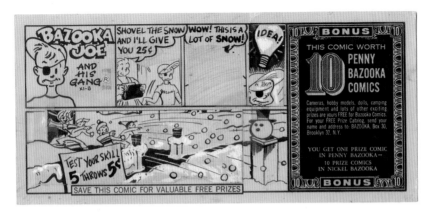

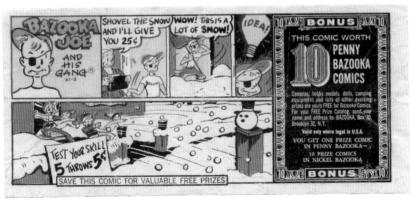

1962

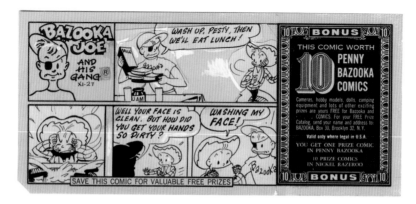

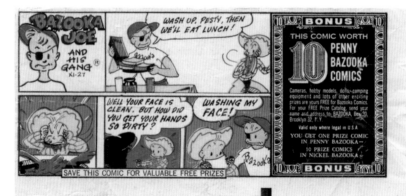

1962

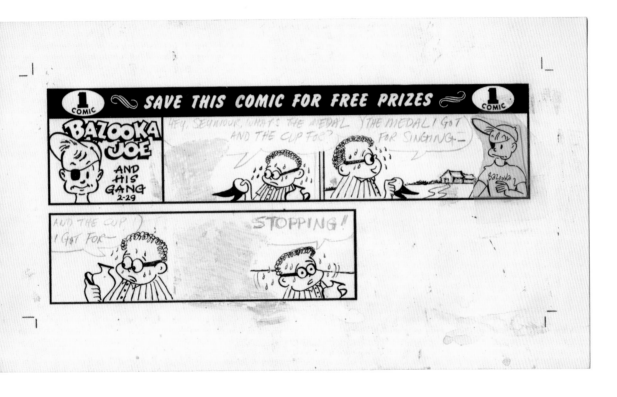

1963

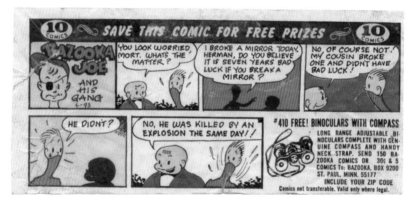

Originally issued in the mid-1960s, this comic caught the attention of Topps management, and was pulled from circulation on February 27, 1970.

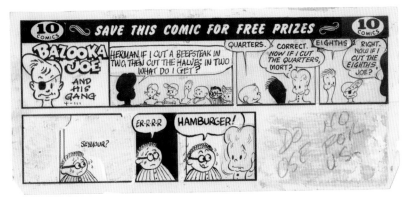

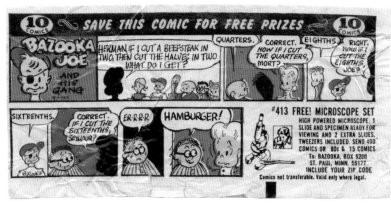

1966

In 1965, Robert Crumb (who had yet to make a name for himself as a cartoonist) started freelancing for Topps after moving to New York to work with Harvey Kurtzman on *Help!* magazine (only to discover the magazine was going under). "The Road to Success" was an incentive booklet intended for salesmen to boost Bazooka sales.

LEFT: Original pencil rough.
RIGHT: Final printed booklet.

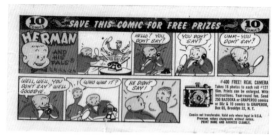

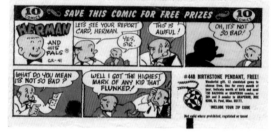

LEFT: Letter from Woody Gelman to the Topps art department regarding Herman Graperoo gum comics, 1963.

RIGHT: Two Herman Graperoo bubble gum comics and exterior wrapper, c. 1963.

TOP: Bazooka Freeze Pops window poster, 1960s.
BOTTOM: Bazooka Twin-EE Frozen Pops box, 1966. It is unknown whether either of these products was ever released.

 Joe Garaqiola
∙∙∙ Bazooka®

BIG LEAGUE
BUBBLE GUM
BLOWING
CHAMPIONSHIP

sponsored by
Topps Chewing Gum, Inc.

1975 JOE GARAGIOLA/BAZOOKA
BUBBLE GUM BLOWING CHAMP

KURT BEVACQUA
MILWAUKEE BREWERS

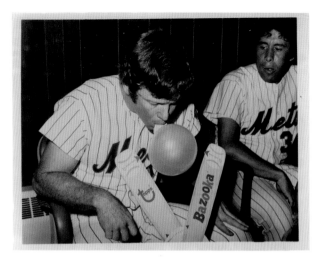

In 1975, Topps held a contest between Major League baseball teams titled the Joe Garagiola Bazooka Big League Bubble Gum Blowing Championship. The best bubble blowers of each team were whittled down in a series of matches held at ballparks around the country, with the finals broadcast on national television. Kurt Bevacqua of the Milwaukee Brewers won with an eighteen-and-a-half-inch bubble, earning a $1,000 dollar prize and a case of Bazooka for himself and for his favorite charity. Topps commemorated Kurt in 1976 with a baseball card of his winning bubble.

OPPOSITE LEFT: Official rule book

OPPOSITE RIGHT: Original Bazooka calipers used during the contest

ABOVE LEFT: Autographed Topps trading card of Bazooka Bubble Gum Blowing Champ Kurt Bevacqua, 1976.

RIGHT: Press photos during team contests and finals. Joe Garagiola was the announcer, with a Major League umpire officiating.

YOU'LL SELL MORE IF YOU STOCK ALL FOUR!

MR. DEALER: FOR MAXIMUM PRODUCT DISPLAY REMOVE THIS COVER

Big Bazooka box panel, 1970s. For this release, a large slab of Bazooka gum was
sandwiched between two trading cards featuring Bazooka Joe comics. Several sets
of cards were issued in this format throughout the 1970s.

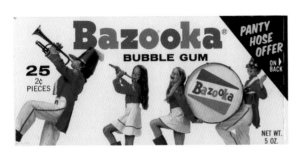

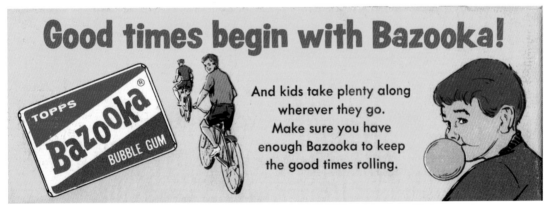

TOP LEFT: Bazooka party box with panty hose offer, c. 1970.
TOP RIGHT: Super Bazooka Chocolate Bubble Gum box panel, 1970s.
 A short-lived flavor from British company Trebor.
BOTTOM: Bazooka box panel advertisement, c. 1970.

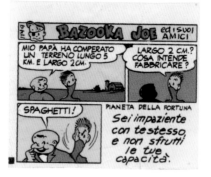

Bazooka comics were translated into many languages beginning in the late 1950s. Pantomime comics, or comics lacking words, could be sold anywhere. The following are just a few examples.

ABOVE, LEFT TO RIGHT, TOP TO BOTTOM: Germany, c. 1960; France, c. 1960; Mexico, c. 1960; Italy, c. 1960.
OPPOSITE: China, 1980s.

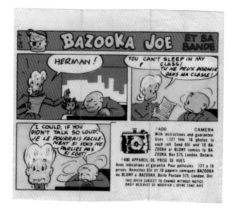

LEFT TO RIGHT, TOP TO BOTTOM: Switzerland, c. 1960; Israel, c. 1960; Canadian Bilingual, c. 1960; International Pantomime c. 1960.

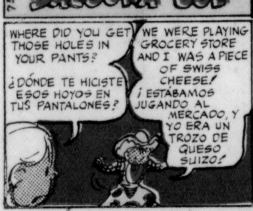

LEFT: U.S. Bilingual, 1973.
ABOVE, TOP TO BOTTOM: Israel, 1970s.
Poland, Turkey, c. 1960s.

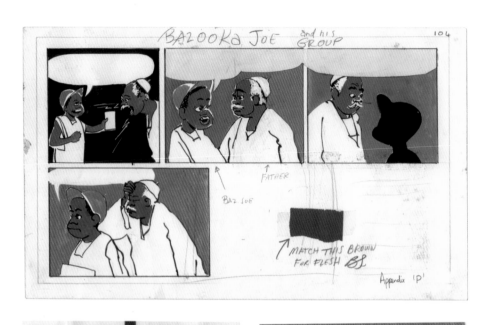

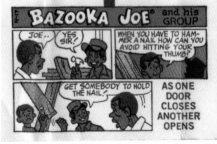

YOUNG NIGERIA'S FAVOURITE
BUBBLE GUM

AVERAGE OF
50 PIECES
BUBBLE
GUM

Cadbury's

Bazooka ®

BUBBLE GUM

OPPOSITE: Nigerian Bazooka Joe original art with
color key, comic strip, and wrapper, 1970s.
RIGHT: Nigerian Bazooka bubble gum box,
licensed by Cadbury, 1970s.

BAZOOKA JOE® RAG DOLL
P. O. BOX 2021
REIDSVILLE, N. C.
27320

REIDSVILLE, N. C.

BULK RATE
U. S. POSTAGE
PAID
PERMIT NO. 166
REIDSVILLE, N. C.

RETURN AND FORWARD POSTAGE GUARANTEED

THIRD CLASS

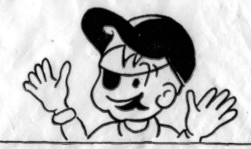

OPPOSITE: Bazooka Joe Rag Doll premium mailer bag, 1973.
ABOVE LEFT: Bazooka Joe Rag Doll premium, 1973.
ABOVE RIGHT: Bazooka Joe Wacky Wobbler bobble head doll
 issued by Funko, 2003

Bazooka Bubble Blowing Toy Gun, 1970s.
International Bazooka Advertising Coin, 1970s.
The Atom Bazooka Bubble Gum Buddy L Toy Car, 1970s.
Bazooka Lip Balm, 1980s.

Bazooka promotional golf balls given to jobbers and retailers, 1960s.
Bazooka Joe candy dispenser, 1960s.
International Bazooka Club toy truck, c. 1960.

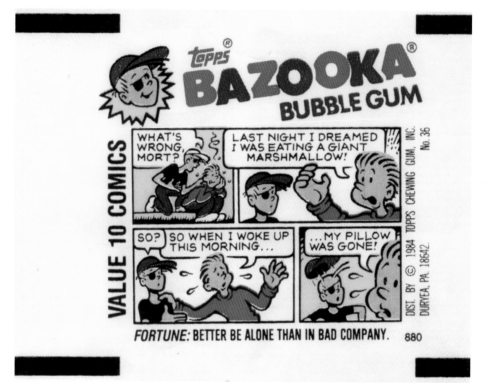

Bazooka Joe and His Gang were relaunched in 1983, introducing several new cast members while dropping others. The series of forty-five comics were illustrated by Howard Cruse and issued through the end of the 1980s.

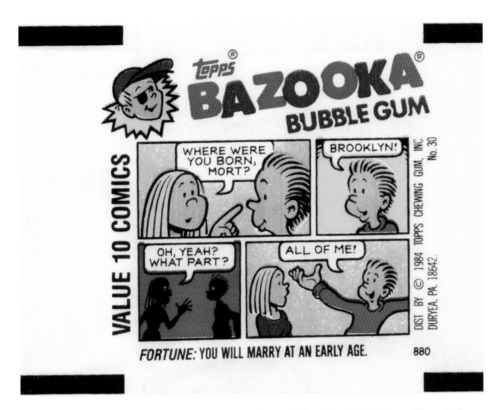

OVERLEAF: Unpublished Howard Cruse instructional comic, mid-1980s. "I always liked this strip because it's practically the only time I was invited to draw the character at a size large enough to allow some stylistic personality."

How to BLOW

Demonstrated by Prof. BAZOOKA JOE

FIRST SOFTEN THE GUM BY CHEWING IT FOR SEVERAL MINUTES...

THEN PLACE YOUR TONGUE BEHIND THE GUM AND PUSH IT FORWARD SO THAT AN AIR POCKET CAN BE FORMED. BLOW AIR INTO THE FLEXIBLE, STRETCHING POCKET SO THAT IT UNIFORMLY ENLARGES AND EXPANDS UNTIL THE BUBBLE IS FORMED...

A BUBBLE!

As UNIFORM AIR PRESSURE IS EXERTED, THE BUBBLE WILL EXPAND IN ALL DIRECTIONS, WITH THE FILM GROWING THINNER AS THE BUBBLE GROWS LARGER...

WHEN THE BUBBLE'S SURFACE BECOMES SO THIN THAT IT NO LONGER HAS FLEXIBILITY, COHESIVENESS AND CONSISTENCY, THE INEVITABLE RESULT WILL TAKE PLACE...

POW!

the end!

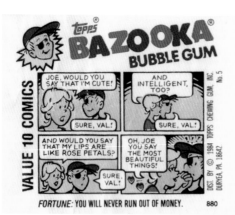

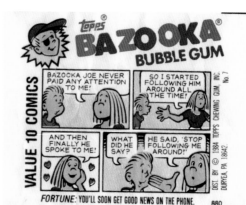

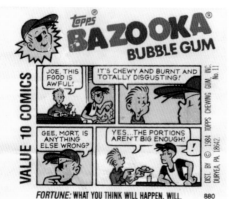

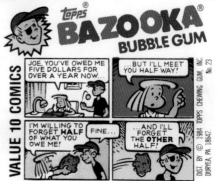

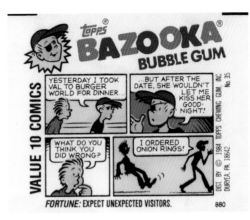

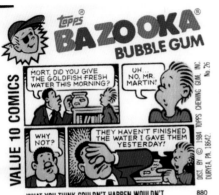

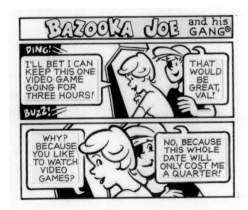

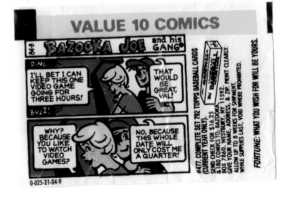

BOTTOM: Howard Cruse original art and finished comic, 1983.

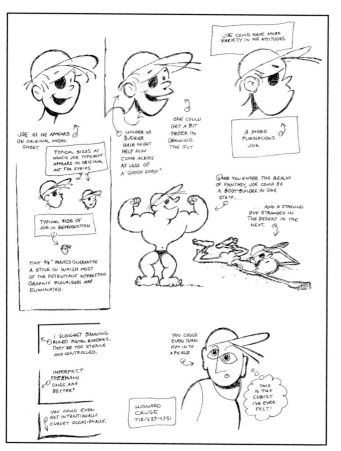

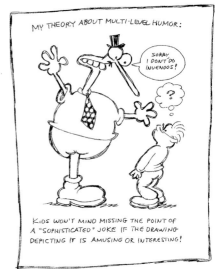

Howard Cruse proposal for 1988 revamp.

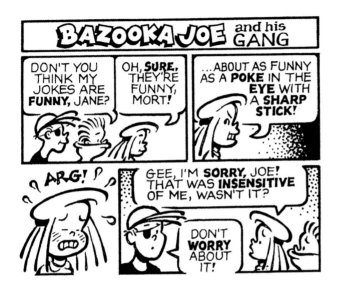

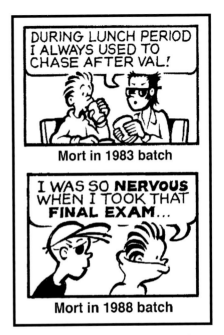

Mort in 1983 batch

Mort in 1988 batch

ABOVE LEFT: "Not-for-actual-inclusion-with-any-gum-package" Bazooka Joe strip from the mid-1980s by Howard Cruse, which he did "strictly for Len Brown and the gang at Topps to enjoy."

ABOVE RIGHT: "When I was asked by Len Brown at Topps in 1983 to reconceive Bazooka Joe as a teenager and provide him with a new 'gang,'" recalls Howard Cruse, "the only holdover from the earlier tykes who had served as his supporting cast was Mort, the weird sidekick who wore a turtleneck pulled up to his eyes. Len and Art Spiegelman, who was consulting for Topps at the time, thought the ultra-lengthy turtleneck was a bit—in fact, was literally—over the top, though. So for my first series of strips the sweater's collar was brought down below Mort's chin where a sweater's neckline should be. Apparently this change disturbed some unnamed traditionalists at Topps, so when I was hired to draw a second batch of strips in 1988, the turtleneck was restored to its original position just under Mort's eyes."

Topps®

BAZOOKA®

BUBBLE GUM NET WT 3.4 OZ.

FUN SURPRISE INSIDE!

BAZOOKA®

BUBBLE GUM

FUN SURPRISE INSIDE!

BAZOOKA®

BUBBLE GUM

FUN
SURPRISE
INSIDE!

© 1985, TOPPS CHEWING GUM, INC., DURYEA, PA. 18642
DEXTROSE, CORN SYRUP, GUM BASE, SUGAR, SOFTENERS, NATURAL &
ARTIFICIAL FLAVORS, COLORING, & BHT (TO MAINTAIN FRESHNESS)

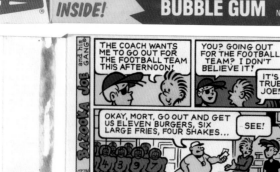

BAZOOKA JOE and his GANG

THE COACH WANTS ME TO GO OUT FOR THE FOOTBALL TEAM THIS AFTERNOON!

YOU? GOING OUT FOR THE FOOTBALL TEAM? I DON'T BELIEVE IT!

IT'S TRUE, JOE!

OKAY, MORT, GO OUT AND GET US ELEVEN BURGERS, SIX LARGE FRIES, FOUR SHAKES...

SEE!

NO. 20

VALUE 50 COMICS

#452. MINI TOOL SET
INCLUDES 7 DIFFERENT PIECES. PLUS
PLASTIC CASE. SEND $1.20 & 90
BAZOOKA COMICS TO: BAZOOKA,
BOX 7860, WESTBURY, N.Y. 11592.
GIVE ZIP. PRINT CLEARLY.

ALLOW 4 TO 6 WEEKS FOR SHIPMENT.
VOID WHERE PROHIBITED, REGULATED OR TAXED.

FORTUNE: BIG SHOTS ARE OFTEN LOW CALIBRE.

BAZOOKA®

BUBBLE GUM

FUN SURPRISE INSIDE!

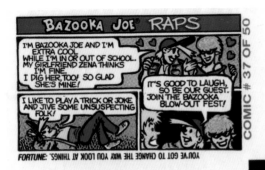

COMIC # 37 OF 50

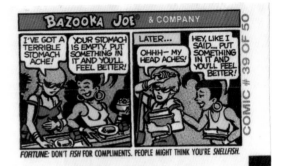

COMIC # 39 OF 50

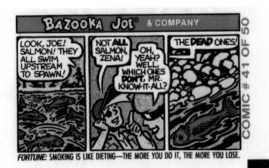

COMIC # 41 OF 50

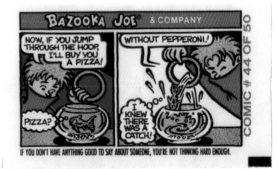

COMIC # 44 OF 50

OPPOSITE: Bazooka party box featuring Howard Cruse comic, 1985.

ABOVE: In 1990, Topps brought in artist Jay Lynch to redesign the cast and ink fifty additional comics. This series ran for over six years and in a variety of formats. Marketing decided to drop "Gang" from the title and replace it with "Company" given the negative connotations of the word "Gang" at the time.

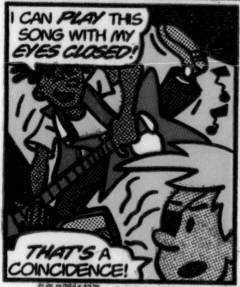

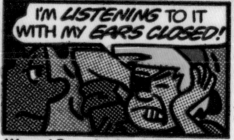

FORTUNE: SOON YOU'LL HAVE BUBBLE GUM ON YOUR FACE.

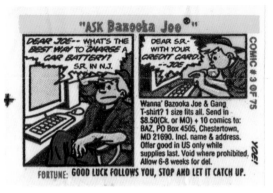

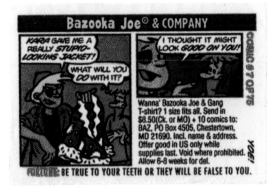

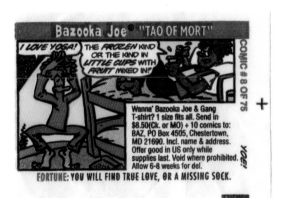

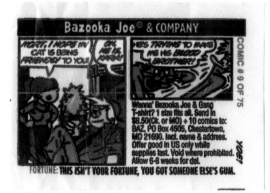

Craig Yoe and Yoe! Studio created yet another redesigned batch of seventy-five comics in 1996.

CHEW! POP! GUM WRAPPERS AREN'T JUST FOR KIDS

BY R. SIKORYAK

In the late 1980s, books such as *Maus*, *Watchmen*, *American Splendor*, and *Batman: The Dark Knight Returns* were changing the public perception of comics from childish fun to sophisticated fine art. The media responded with articles about how "pictorial narratives" were finally growing up. This emboldened artists and publishers to create more ambitious, literary comics. But Topps, bless them, remained true to their original vision of *Bazooka Joe*: old-fashioned, disposable gum wrappers. In 1987, I was honored and privileged to briefly write for *Bazooka Joe,* in the process exploring and attempting to expand their long, storied legacy—while being paid a reasonable per-gag rate.

No one would call the *Bazooka Joe* strips timeless and intelligent graphic-novella packaging for mature audiences.

But *Bazooka Joe* can hold great pleasure for adult comic strip aesthetes and ironic postmodernists like myself. There is a wonderful purity in the rigid format of comic-plus-ad-plus-fortune, the economy of storytelling, and the comic archetypes of the *Bazooka* cast. It also helps if you're a fan of extremely corny jokes.

But back in the late eighties, having just graduated from Parsons School of Design in New York, I struggled to make my way as an illustrator and cartoonist through various freelance jobs. I drew diagrams for humorless medical textbooks, did production work at Art Spiegelman and Françoise Mouly's Raw Books, and toiled away on my own postmodern comic strips.

I was one of many freelance artists brought into Topps by Art Spiegelman, and there I worked with him and Mark

Newgarden. I'd previously attended some classes they taught at the School of Visual Arts, where I learned a lot about the formal and storytelling properties of comics. Art and Mark had an appreciation for all kinds of comics, from the brilliant to the low-brow (which are not mutually exclusive, of course), and I began regularly visiting the Topps offices in Brooklyn, where I would get my freelance assignments.

I illustrated designs for various products, such as Sneaky Snacks (plastic candy containers disguised as notebooks, pencils, erasers, and other school supplies); wrote gags for the backs of trading cards, including Garbage Pail Kids, which were still wildly popular and going into their fourteenth series; and was tapped to sketch comics stories for Topps's longest-lasting cultural phenomenon, *Bazooka Joe.*

Every week I'd brainstorm four to six *Bazooka* strips and doodle them out in a very rudimentary style. I roped my brother, Steve, into suggesting additional ideas that I then sketched—his appreciation for bad puns and stale gags probably exceeds even mine. With the same methods I used as a kid, I drew tiny images with magic markers on scrap photocopy paper, and used white tape for corrections. My total cost for materials was about $3.15. Although my scribbled layouts had none of the flair—or even the consistency—of Wesley Morse's dashed-off original strips of the fifties, the plan was for my approved gags to be rendered by the legendary Howard Cruse, who had been drawing the more recent *Bazooka Joe* series since 1983 in a simplified version of his crisp, signature style.

One night, walking to the train on my way home, I noticed a gum wrapper among the litter, and was thrilled to realize that soon my work would be joining it as detritus on the urban landscape. I had truly arrived! Working for Topps would be the height of my freelance career.

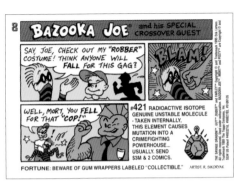

Bazooka Joe-Savage Dragon crossover chrome trading card, back by R. Sikoryak (left) and front by Erik Larsen (right). Image Universe, Topps, 1995.

But how does one carry these characters into a new decade, and flesh them out and reimagine them for a new audience? Actually, it's best if you don't. The idea was to continue the tradition of short, snappy gags with the current gang of characters. It would have been a betrayal of the original comics to deviate from their one-dimensional personalities. Besides, as each comic was printed at 2.5 square inches, the physical strip barely had any dimension whatsoever.

One of the pleasures of the traditional comic strip is the conciseness of words and pictures, and the *Bazooka* format takes this compression about as far as humanly possible. While many comic books in the late eighties were extending page counts and reinventing panel layouts, *Bazooka Joe* remained constrained to three or four panels. Each situation had to be boiled down for near-instant comprehension. My strips contained an average of approximately thirty-five words. As with haiku, there is a great power in the constraints that must be respected by obeying a format. The current layout allowed for a full

rectangle of two tiers, rather than the classic L-shaped strip of the 1950s. (The extra space almost felt like cheating—did *Bazooka Joe* really *need* that additional ¾ inch by ½ inch–panel space in the second row?) The text for the fortunes and prizes were to be written by others.

Studying the library of thirty years of strips available at the Topps offices, I found a consistency of voice in the *Bazooka* oeuvre. Despite the change in art styles, many known and anonymous authors contributed to make a singular vision out of a series of shticks. Once I read enough of the strips, it was easy to latch on to their worldview. The 1980s strips relied on a few broad topics: mostly homework, cars, music, food, television, and relationships. Within those themes there were a lot of variations; the job was to dig them up and keep them simple. Also, to best utilize the limited space, the visual tropes were crucial: flying feet, flying sweat, and flying punctuation (both exclamation points and question marks). These were employed over and over, either individually or collectively, mostly in response to the verbal punch lines.

Who were the characters at that point? There was our protagonist, Joe, a typical teen with an eye patch. He was joined by Mort, his wacky best friend and a neurotic sweater-wearer. Val was the reliable, long-suffering, blond love interest. In a radical break from industry standard, she was not joined by a nearly identical brunette love interest. Supporting characters included Shades, the snarky, vaguely new-wave/eighties teen antagonist; Blotch, Shades's sunglass-wearing shaggy dog; Mr. Martin, the well-meaning mustached teacher; and Jane, Joe's little sister. You'll note that their chief character traits are hair color, height, or fashion sense.

The character with the most potential was clearly the loose cannon, Mort, and I was relieved to learn that Mort would again be wearing his collar over his face. For some reason, his entire face was visible in the 1983 series, which

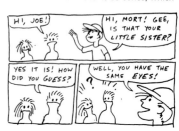

Unpublished Bazooka Joe gag layouts by R. Sikoryak, c. 1987.

I felt completely forsook the character. (I believe Mort's sartorial choice is even more crucial to his power than bat ears are to Bruce Wayne's.)

The one addition I hoped to make to the canon was a new relative of Mort's: a younger sister, with a nearly identical crazy-haired, sweater-fixated appearance. I suppose her name would have been . . . Mortina? But the strip was rejected. Possibly her presence would have altered the delicate dynamics of the cast and thrown off the perfect balance of characters. Mort should probably remain an only child. When it comes to neurotic sweater-wearing icons, there can be only one.

I don't recall getting too much feedback from Art and Mark, except for an occasional audible groan for the oldest and lamest jokes I tried to incorporate. (Jane: "Does your dog bite?" Kid: "Nope." Dog: *"Chomp!"* Jane: "You said your dog didn't bite!" Kid: "That's not my dog!") They would usually read the strips and check off their favorites. I seemed to have a knack for miniaturized comics—I sold a few every week, and kept at it for a while.

After two or three months of submissions, I learned Topps had decided not to continue the Cruse-illustrated series, but to reboot *Bazooka Joe* from scratch once again. None of my scripts saw print (they are being shown here for the first time). But during that period it was very satisfying to write such pure comics.

Bazooka Joe has reentered my life a few times since then, and hopefully he will again. In 1989, for *Raw* magazine, I created what I hoped would be the definitive Bazooka statement: Inferno Joe, a parody that retold the entirety of Dante's *Inferno* in ten wrappers, using Wesley Morse's original cast. But no parody can be definitive; there's always another spin. In 1994, for a crossover with Image Comics and Topps, I drew a meeting of Joe, Mort, and Erik Larsen's super hero, Savage Dragon. Because Topps published it, I assume "Bazooka Joe and His Special Crossover Guest" is considered a canonical story. Topps hasn't established alternate universes for different incarnations of its characters—yet. And in 2008, for *The Onion* newspaper, I illustrated an article on the shocking secret beneath Mort's sweater.

Now that *Bazooka Joe* has warranted the deluxe hardcover book treatment, it isn't hard to imagine the strip evolving for the new century and joining the ranks of more stately graphic novels. Perhaps an artisanal vegan gum maker in a hip Brooklyn neighborhood will license the characters to be printed on its acid-free archival wrapping paper. Whatever the future holds for the gang is unknown, but most likely it will be epigrammatic and ambrosial. Or, to put it more simply: short and sweet.

R. SIKORYAK is the author of *Masterpiece Comics* (Drawn & Quarterly). His drawings have appeared in many magazines, several books, and a few television shows. He teaches and lectures on comics and illustration, and hosts the live traveling comics reading series, *Carousel*.

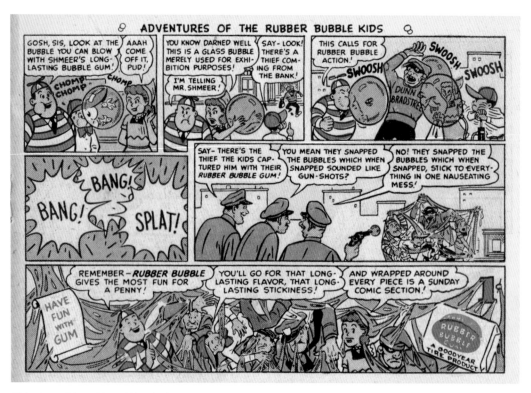

"Adventures of the Rubber Bubble Kids" by Harvey Kurtzman and Will Elder from *MAD* no. 21, published by E.C. Publications, Inc., in March 1955. This Kurtzman-Elder classic was a parody of the character Pud and a brand of bubble gum from Fleer called Dubble Bubble, which pre-dated Bazooka Joe and Bazooka bubble gum. The satires of Kurtzman and Elder were huge influences on many of the writers and artists who worked for Topps over the years.

An alleged "controversial strip" that ran in the October 30–November 5, 2008 issue of *The Onion*. This illustration by R. Sikoryak accompanied the parody article "Burned Lower Half of Mort's Face Revealed in 'Bazooka Joe' Stunner."

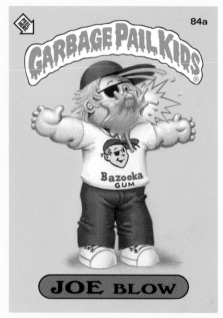

Topps parodied their own Bazooka brand on several occasions. LEFT: "Gadzooka," *Wacky Packages* sticker no. 5 by Norm Saunders (Series 1, 1973). RIGHT: "Joe Blow/Rod Wad," *Garbage Pail Kids* sticker no. 84 and pencil sketch (opposite left) by John Pound (Series 3, 1986).

B32
BAZOOKA JOE

GARBAGE PAIL KIDS

Bazooka

POUND

pencil art for GPK #84 (series 3, 1986)
JOE BLOW / ROD WAD

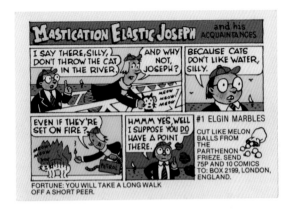

MASTICATION ELASTIC JOSEPH and his ACQUAINTANCES

I SAY THERE, SILLY, DON'T THROW THE CAT IN THE RIVER.

AND WHY NOT, JOSEPH?

BECAUSE CATS DON'T LIKE WATER, SILLY.

MEOW MEOW MEOW

EVEN IF THEY'RE SET ON FIRE?

MEOW MEOW

PETROL

HMMM YES, WELL I SUPPOSE YOU DO HAVE A POINT THERE.

#1 ELGIN MARBLES
CUT LIKE MELON BALLS FROM THE PARTHENON FRIEZE. SEND 75P AND 10 COMICS TO: BOX 2199, LONDON, ENGLAND.

FORTUNE: YOU WILL TAKE A LONG WALK OFF A SHORT PEER.

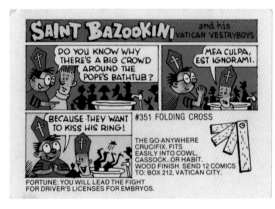

SAINT BAZOOKINI and his VATICAN VESTRYBOYS

DO YOU KNOW WHY THERE'S A BIG CROWD AROUND THE POPE'S BATHTUB?

MEA CULPA, EST IGNORAMI.

BECAUSE THEY WANT TO KISS HIS RING!

#351 FOLDING CROSS
THE GO-ANYWHERE CRUCIFIX. FITS EASILY INTO COWL, CASSOCK, OR HABIT. WOOD FINISH. SEND 12 COMICS TO: BOX 212, VATICAN CITY.

FORTUNE: YOU WILL LEAD THE FIGHT FOR DRIVER'S LICENSES FOR EMBRYOS.

Bazooka parody postcards illustrated by Ron Barrett, issued by Tart Graphics, Inc., 1970s.

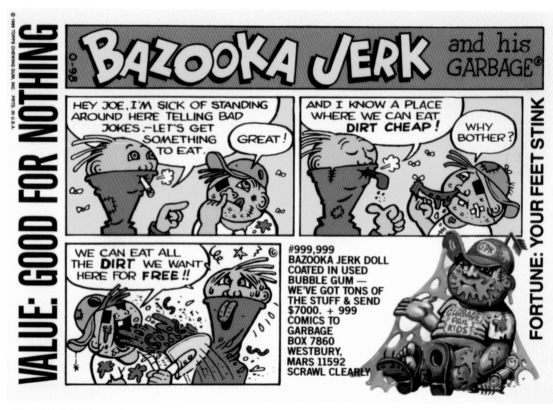

"Bazooka Jerk," *Garbage Pail Kids Giant Series* sticker no. 1, 1986. Front (above) illustrated by Tom Bunk, and back (opposite) illustrated by Howard Cruse.

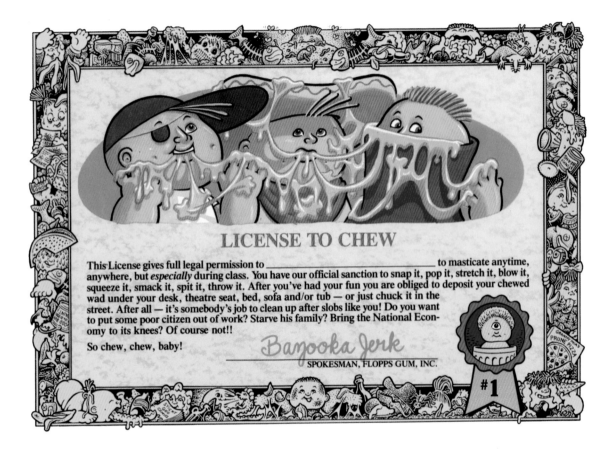

LICENSE TO CHEW

This License gives full legal permission to _____ to masticate anytime, anywhere, but *especially* during class. You have our official sanction to snap it, pop it, stretch it, blow it, squeeze it, smack it, spit it, throw it. After you've had your fun you are obliged to deposit your chewed wad under your desk, theatre seat, bed, sofa and/or tub — or just chuck it in the street. After all — it's somebody's job to clean up after slobs like you! Do you want to put some poor citizen out of work? Starve his family? Bring the National Economy to its knees? Of course not!!

So chew, chew, baby!

Bazooka Jerk

SPOKESMAN, FLOPPS GUM, INC.

#1

IN THE LAND OF THE BLIND, THE ONE-EYED MAN IS KING*

BY JAY LYNCH

Nineteen fifty-three was the year of the eye patch. David Ogilvy's ad campaign, "the Man in the Hathaway Shirt," which was introduced in 1951 and featured a distinguished looking gentleman (Baron George Wrangell) wearing an eye patch, was an advertising sensation. In the funnies, Brenda Starr had been having a series of synchronistic encounters with the enigmatic Basil St. John, whose eye patch added to his mystique. And if you watched television, you were likely to see the Will Mastin Trio with Sammy Davis Jr. on the *The Ed Sullivan Show*. Sammy had been in a car accident, lost his left eye, and began sporting an eye patch, as did Zsa Zsa Gabor, who was putting a public-sentiment spin on her allegation that

*Sixteenth-century proverb

her then-current beau, the international playboy Porfirio Rubirosa, had given her a black eye. And written in first person, with the author as main character, Steve Harragan's series of crime-fiction paperbacks, with titles like *Side-Show Girl* and *Sin Is a Redhead*, were all the rage in 1953, with Harragan always sporting a black eye patch on the covers.

With all this Zeitgeist (or should one say, Sightgeist?) Bazooka Joe was given an eye patch as well. Back then an eye patch, it seemed, was the ticket to mass cultural recognition. So you can't blame Woody Gelman (head of product development at Topps), freelance artist Wesley Morse, and art director Ben Solomon for outfitting Joe with one. Today Topps's official statement on Joe's eye patch is that it's just an affectation. Joe has two good eyes, but

he wears the patch because it makes him look distinctive. For Joe, the eye patch is a fashion statement. You can't slight him for that. Justin Bieber wears dog tags, but he's never been in the military.

These days the name "Bazooka Joe" has entered the vernacular. Montana Gold brand acrylic spray paint comes in a variety of colors. The bubble-gum-pink hue is called Bazooka Joe. There are and were a number of rock bands called Bazooka Joe, the most famous being the one in which Adam Ant got his start in the 1970s. But that doesn't prove much. Any word or phrase in the English language that you might choose to Google these days will likely turn up a rock band or two by that name. In bars, there is a mixed drink called Bazooka Joe. There are a wrestler and a disc jockey

who each call themselves Bazooka Joe. In Chicago, there is even a male stripper who goes by that handle.

Not surprisingly, after sixty years, the character has become a cultural icon. It's safe to say that Bazooka Joe is the most well-known character on the planet associated with a confectionery company. At one point in the late sixties, with a billion pieces of Bazooka gum being sold worldwide every year, *Bazooka Joe*'s gag writers found themselves the holders of the title of the world's bestselling authors. World's most *widely read* authors, though? I'm not too sure of that. But in the seventies, if you were to go to almost any country in the world and look in the gutter, you couldn't walk fifty feet without seeing a crumpled-up *Bazooka Joe* comic. Paris? São Paulo? Istanbul? It didn't matter. You couldn't miss him.

RIGHT: The 1951 "Man in the Hathaway Shirt" ad campaign (featuring Baron George Wrangell) from David Ogilvy and the Ogilvy & Mather ad agency was the inspiration for Bazooka Joe's eye patch.

Baron Wrangell with Univac — Sperry Rand's electronic brain.

Indigo—Hathaway's new devil-may-care color

THIS DARLING indigo is Hathaway's protest against those wishy-washy shades that have become so deplorably common. We intend it to sound a clarion call for bolder male plumage.

In this same range, Hathaway offers rust, olive, gold, mountain ash, berry red.

The fabric comes from England. A particularly fine double-spun broadcloth, the kind usually reserved for *evening* shirts. The style is Hathaway's remarkable new Suburban—a cunning cross between office and country cut. Unlike sports shirts, it comes in exact neck and sleeve sizes.

Ask to see these shirts at stores which keep up the great tradition. Price $10.95. For the name of the store nearest you, write C. F. Hathaway, Waterville, Maine.

Art Spiegelman gave me my first freelance *Bazooka Joe* gag-writing gig back in 1967, when he was working full time in the Topps creative department. Trying to recall work on *Bazooka Joe* from almost fifty years ago is what you might call looking through an eye patch darkly. Most of us have hazy memories of the actual work we did at Topps. I can, however, easily remember what we ate for lunch in the Topps cafeteria. Woody Gelman, for example, would have a meat loaf sandwich. Len Brown (creative director) and Rich Varesi (from product development) would go down the street a lot and have baked ziti at a storefront eatery.

To jog my memory, I phoned Art to see what he remembered about our Bazooka Joe days. After recalling some interesting lunches at the Burger King down the street from Topps, Art related an amusing anecdote: At one point he had come down with conjunctivitis and had to wear an eye patch for a few days. When he came into the office, Woody Gelman's secretary, Faye Fleischer, saw Art first. She pointed to the eye patch and kiddingly said, "Bazooka Joe!" As Art passed Woody's office, Woody looked out his door and quipped, "Bazooka Joe!" Walking a little farther, Art was stopped by Len Brown, who looked at

Art and chuckled, "Bazooka Joe!" Finally Abe Morgenstern (a longtime product development executive at Topps) came out of his office. Abe looked at Art's eye patch and immediately exclaimed, "Moshe Dayan!" I suppose everyone's personal Bazooka Joe lies in the eye of the beholder.

The humor of the *Bazooka Joe* comics has always been the topic of one-sided debate. Two-time Pulitzer Prize–winning journalist and humorist Gene Weingarten wrote the following in his column in the *Washington Post* on September 5, 2010: "'Bazooka Joe' comics are not juvenile humor and never were. Over the years, they have been

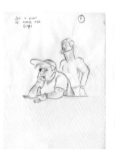

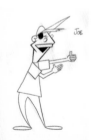

secretly written by a series of brilliant satirists—including Groucho Marx, René Magritte, Woody Allen, and Garry Trudeau—in a long-running, highly sophisticated sendup of bad humor. As such, they are actually the highest form of humor. So are 'your momma' quips."

Although Weingarten's comment was meant to be facetious, it well may be that he actually hit the proverbial nail on the head. True, Groucho, René, Woody, and Garry weren't among the gag writers on these things. But the real list of the then down-and-out crowd of anonymous freelancers and the nine-to-fivers in the Topps offices who came up with these old vaudeville-style gags was almost as impressive. But we'll get to that momentarily.

Wesley Morse, who had been drawing *Bazooka Joe* since the strip began in 1953, passed away in 1963. But he had completed enough *Bazooka Joe* strips to last another twenty years or so. Topps would slowly trickle out these previously unseen comics, and each new

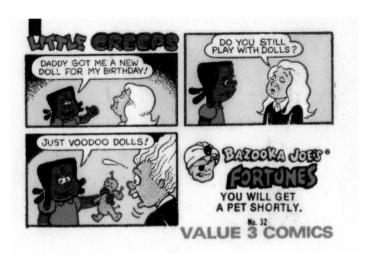

Bazooka Joe series would be padded with other strips that would run during those post-Morse years under the title "Bazooka Joe Presents." Some of these were gags that parodied *Ripley's Believe It or Not!* Some of them were "Bazooka Joe's Funny Fortunes," which would be illustrated gag fortunes that would comprise the entire strip. Or they would be gags that introduced new sets of characters.

OPPOSITE: Jay Lynch character studies, 1990. ABOVE: "Little Creeps" gum comic written and illustrated by Jay Lynch, c. 1981.

213

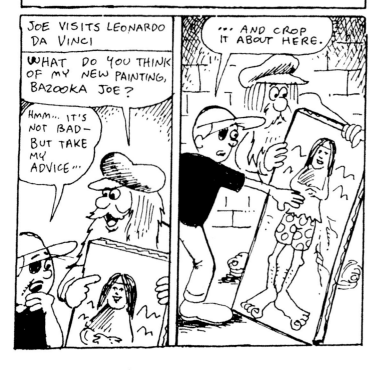

I remember writing and drawing one of these subseries of tiny comics called "Little Creeps," which had gags presented by a cast composed of Frankenstein, Wolf Man, and Dracula as children. (Later I pillaged the gags from Little Creeps and used them as comic strips on the backs of the Garbage Pail Kids cards, redrawing them for that series.) But the new *Bazooka Joe* comics published during the late sixties to the end of the seventies still included the rare and finite fast-dwindling supply of unpublished Wesley Morse strips. During these years, many now-forgotten freelance artists were hired to draw new *Bazooka Joe* images for "Learn Spanish with Bazooka Joe" and "Learn French with Bazooka Joe," which were additional strips created to pad out each new series. But by 1983, the previously unpublished Morse-drawn material had run out, and Topps hired cartoonist Howard Cruse to redesign the characters

Layout by Jay Lynch, 1990.

as teenagers, as well as introduce a whole new crop of supporting cast members to fill out Joe's gang.

As I recall, as time went on these comics had to be printed with vegetable-based ink (in case some really dumb kid decided to eat the comic strips). The ink, combined with the fact that they were printed on wax paper, made the final images look less sharp than if they were printed on regular paper. The only way you could print on a wax stock at that time was by using the flexography method of printing, which was kind of crude. So not only were the comics tiny and the color palette limited, they'd often come out blurry.

Despite the brand managers and marketing companies responsible for the various revamps of *Bazooka Joe* over the years, and their valiant attempts to make the characters and the gags more "hip," I've always thought that the primary appeal of these tiny comics was their overall lameness. Back when I wrote *Bazooka Joe*, I'd usually start by going through turn-of-the-century joke books and rewriting the ancient quips to turn the 1908 ragtime aficionados into 1990s heavy-metal enthusiasts, updating the corny old gags a bit to make 'em understandable to the new generations of kids to whom *Bazooka Joe* was their first introduction to classic American humor. It was always my belief that the more forgettable the gag the better. That way, when a kid bought another piece of gum a week or so later, he would have no recollection of the gag he had gotten previously. So even though he might conceivably get the same gag again and again, it would always be new and fresh to him.

Let's face it, just leaf through the pages of this book or Google "Bazooka Joe and His Gang" online and you'll see what I mean. Bazooka Joe has become the personification of the lowest form of humor. And *this* is why he's one of the most widely known comics characters on the planet. Sure, the gags were cornball. But that's their appeal. And, as Gene Weingarten waggishly postulates, I actually *do* think every gag writer who ever worked on *Bazooka Joe* realized that the strip *is* a conscious effort at stale humor. That's what makes it memorable. Bazooka Joe, by his very nature, *is* corny, retro, old-school, or whatever you want to call it. It's intentionally lame. His gags have *always* been groaners. So let's embrace it: Lame is the new hip!

Over the years, references to Bazooka Joe continue to infiltrate prime-time television sitcoms, Just do a search on YouTube—segments of most of these are viewable there. On one episode of *Seinfeld* from 1991, Jerry pulls his turtleneck up over the lower part of his face. Elaine looks at him with befuddlement as Jerry explains: "Bazooka Joe!" Of course he means Mort—but the confusion is understandable. Besides, who am I to criticize Jerry Seinfeld?

In an episode of *3rd Rock from the Sun* from 1996, John Lithgow sits in front of hundreds of pieces of Bazooka, loading his mouth with the gum as he rapidly opens piece after piece. After

reading each comic strip with no reaction whatsoever, and while chewing a dozen pieces of gum at the same time, he exclaims in frustration, "Oh, Bazooka Joe . . . You're an *imbicile!*" He then spits out the gum into a giant glass jar loaded with even more large wads of expectorated Bazooka bubble gum.

Hundreds of parodies of *Bazooka Joe* have appeared in print over the years as well. The most notable can be found in the pages of *National Lampoon*, *The Onion*, and *MAD*. Newspaper comic strips like *Zits* and *Zippy the Pinhead* have even parodied *Bazooka Joe*. And always, the essence of the parody has to do with the dumbness of the gags. No news flash here.

As for me, I wrote *Bazooka Joe* gags for decades. But the list of those who also worked on *Bazooka Joe* is a long one. I never saved any of the printed comics I wrote, and never thought much about it over the years. I don't think anyone who worked on writing these gags thought much about

it, really. It was a job, and it payed the bills. But the gag writers for this finely honed pap *did* indeed include many of the finest satirists of the twentieth century, just as Gene Weingarten says. Only their names are Len Brown, Woody Gelman, Art Spiegelman, Bhob Stewart, Mark Newgarden, Bob Sikoryak, and pretty much everyone who worked at one time or another in the Topps creative department, when we weren't otherwise too busy. Even the guy who ran the stat machine in the art department at Topps, the aptly yclept Sy Goodstadt, wrote an occasional *Bazooka Joe* gag.

When we *were* involved with tight deadlines on other projects, freelancers were hired to write *Bazooka Joe* gags. Guys like John Holmstrom (the founder and editor of *Punk* magazine), Victoria Zielinski (who went on to be the supervising producer of the documentary *Richard Pryor: Comic on the Edge* for the Biography Channel), Paul Barrosse (later to become a writer for *Saturday Night Live* and head writer on *Totally Hidden*

Video and VH1's *Behind the Music*). There were also cartoonists like Jim Siergey, Howard Cruse, J. D. King, Paul Karasik, Peter Poplaski, Carole Sobocinski, Grass Green, Julie Sczesny, Doug Rice, Craig Yoe, Peter Bagge, Gary Whitney, and John Marshall. The list goes on and on. Many of the early *Bazooka Joe* gags were written by Stan Hart, who later wrote for *Rowan & Martin's Laugh-In* and *The Carol Burnett Show*. And I do recall that quite a few other even more famous and respected American satirists did indeed, at one time or another in their early careers, write for *Bazooka Joe*. I'd like to print the names of those superstars of satire here, but when I sought confirmation of their contributions, none of them would return my calls.

JAY LYNCH is the author of *Otto's Orange Day* (2008) and *Mo and Joe: Fighting Together Forever* (2009) for Toon Books, and has written for *MAD*, *Cracked*, *Sick*, *Playboy*, and *Time* magazines. He has been freelancing for Topps for almost fifty years, and helped create some of their most popular humor products.

This timeline illustrates the various packaging changes to Topps and Bazooka bubble gum over the last seventy-five years. Although far from complete, this is the most comprehensive accumulation to date.

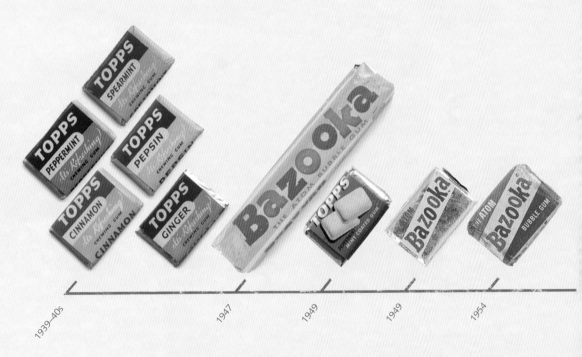

1939–40s 1947 1949 1949 1954

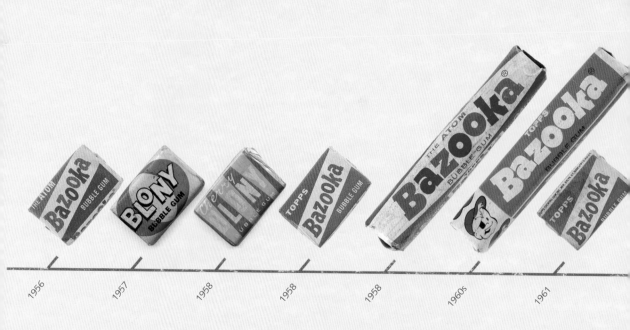

1956 1957 1958 1958 1958 1960s 1961

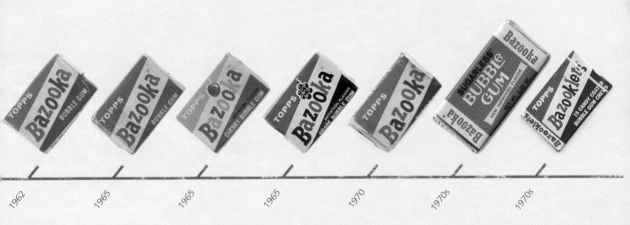

1962　　1965　　1965　　1965　　1970　　1970s　　1970s

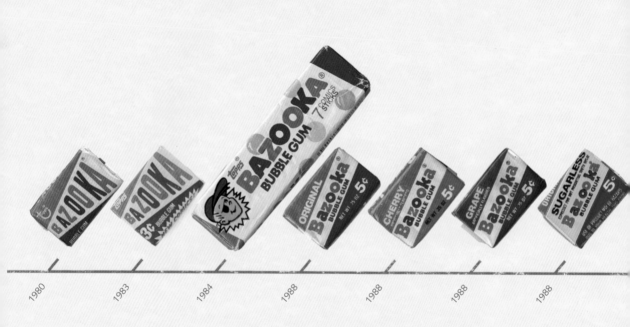

1980 1983 1984 1988 1988 1988 1988

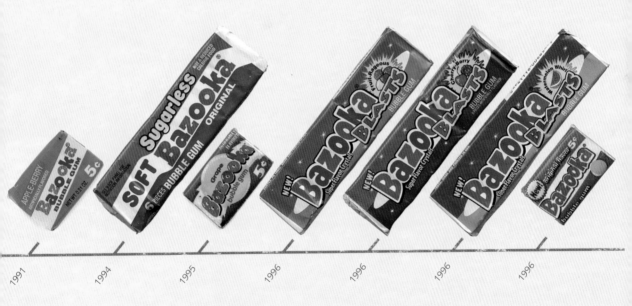

1991 1994 1995 1996 1996 1996 1996

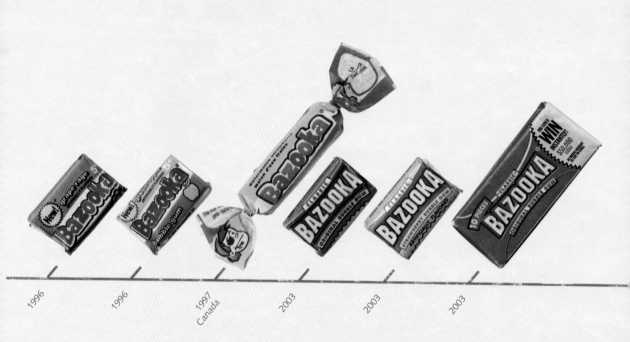

1996　　　　1996　　　1997　　　　2003　　　　2003　　　　2003
　　　　　　　　　　　Canada

2006 2007 2008 2013

223

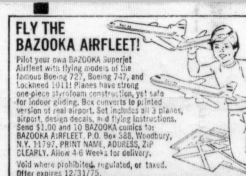

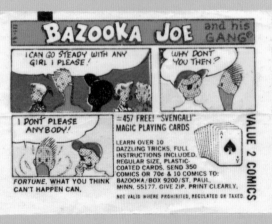

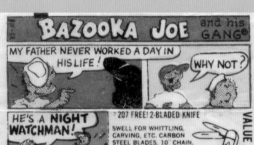